ANIMAL THEME ADULT COLORING BOOK

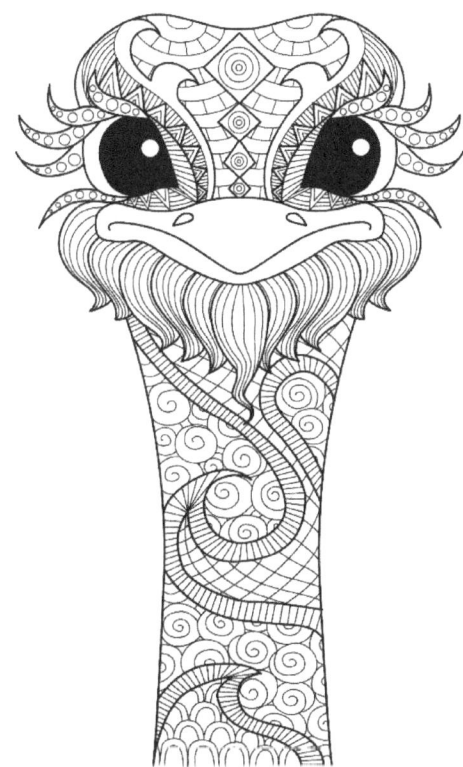

Gail Kamer

All rights reserved.

Above and front cover credit: Bigstockphoto.com: Bimbimkha- 105327353

Illustration credit: Bigstockphoto.com: Panki- 128504084

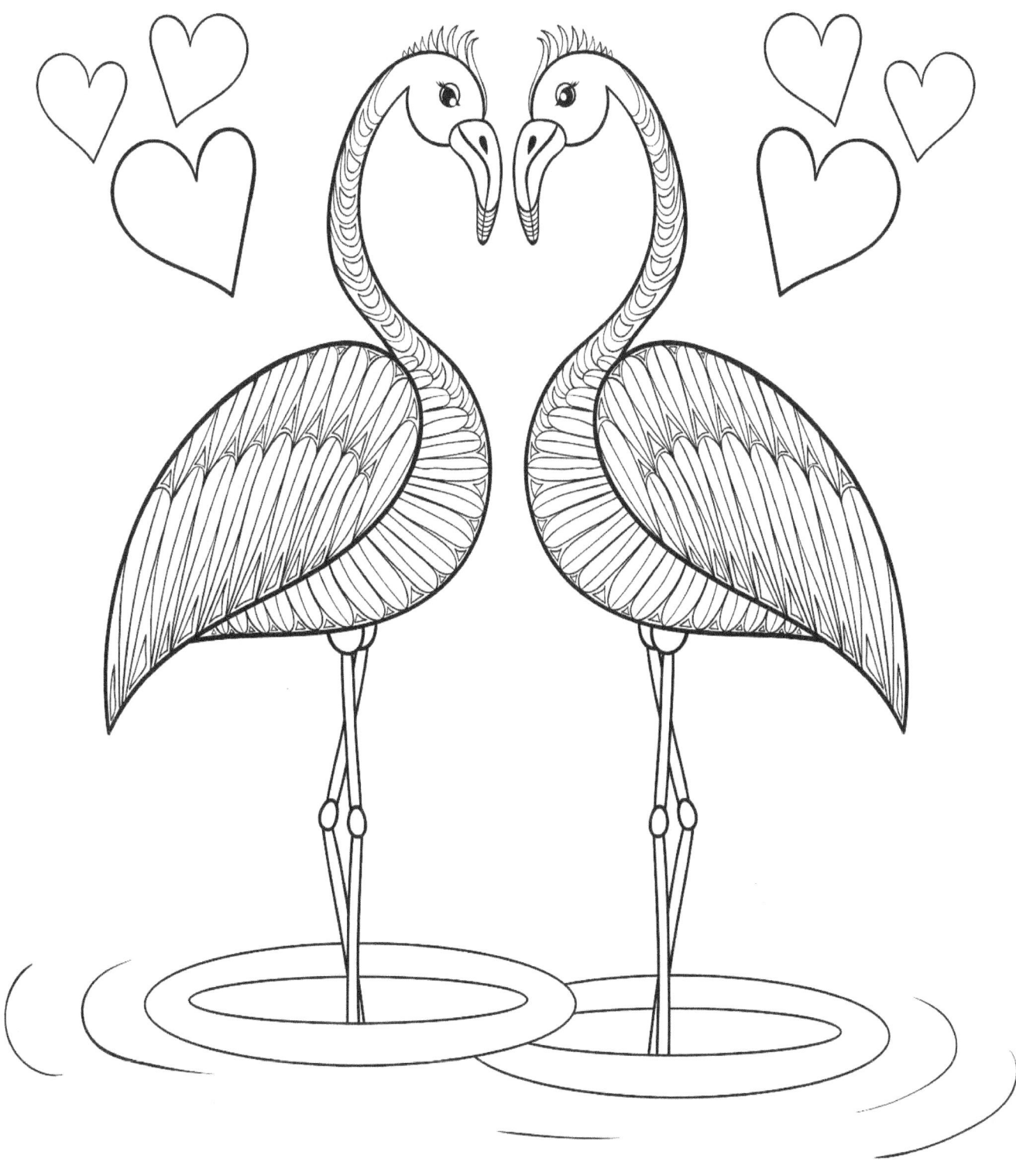

Illustration credit: Bigstockphoto.com: Sybirka-121616690

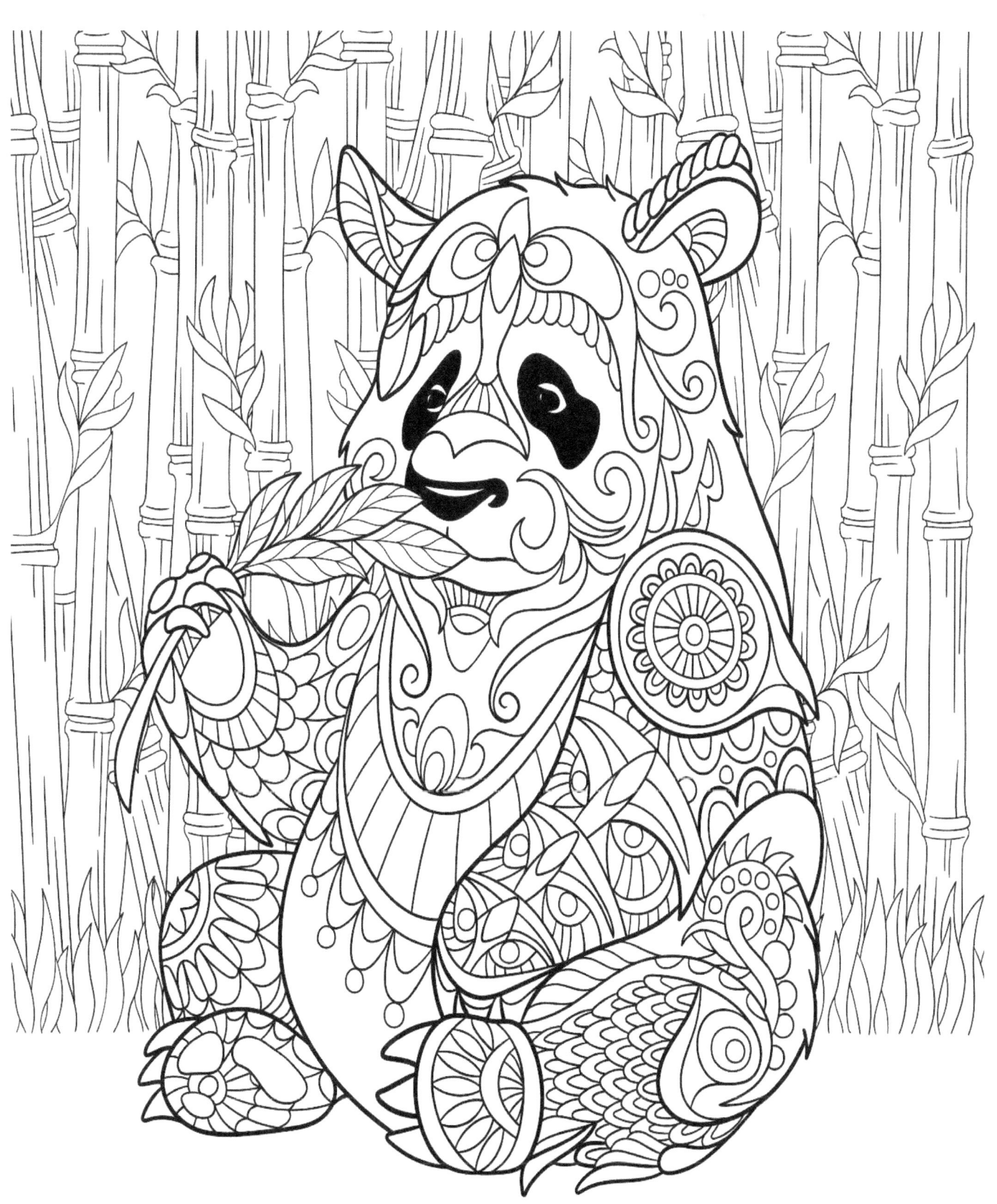

Illustration credit: Bigstockphoto.com:Sybirko- 120093035

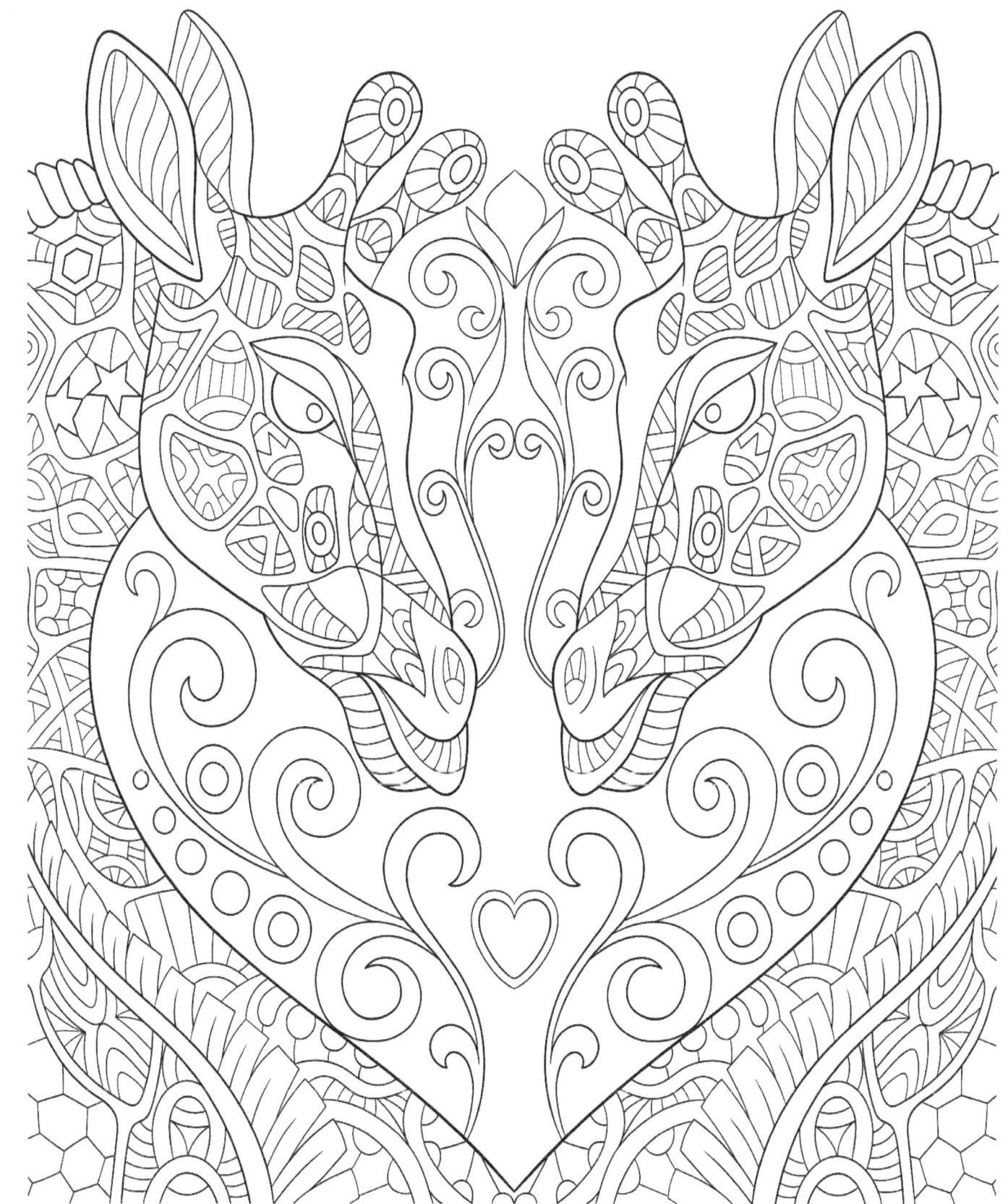

Illustration credit: Bigstockphoto.com: Viacheslav Dubrovin- 132020405

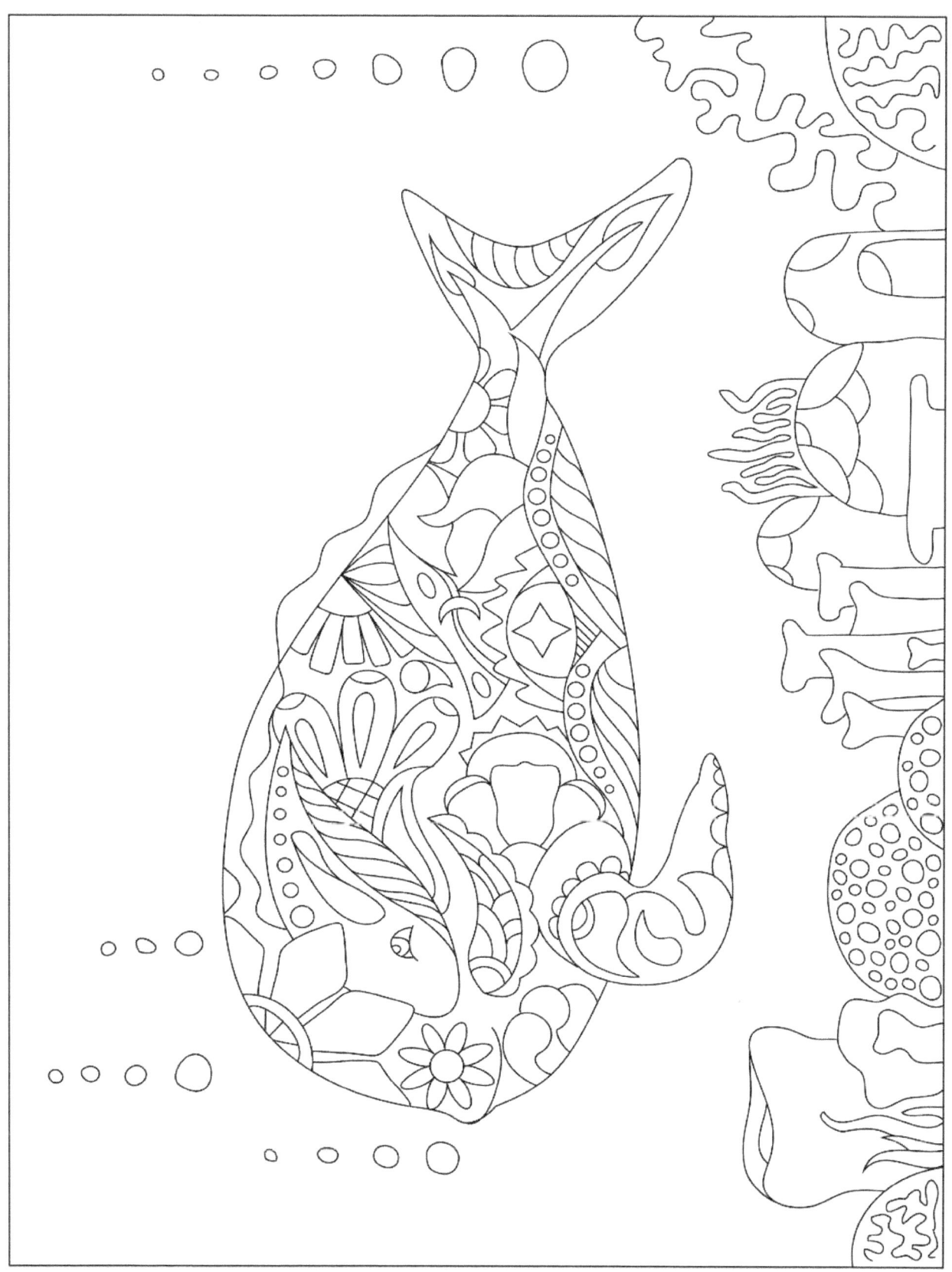

Illustration credit: Bigstockphoto.com: Peliken- 140855951

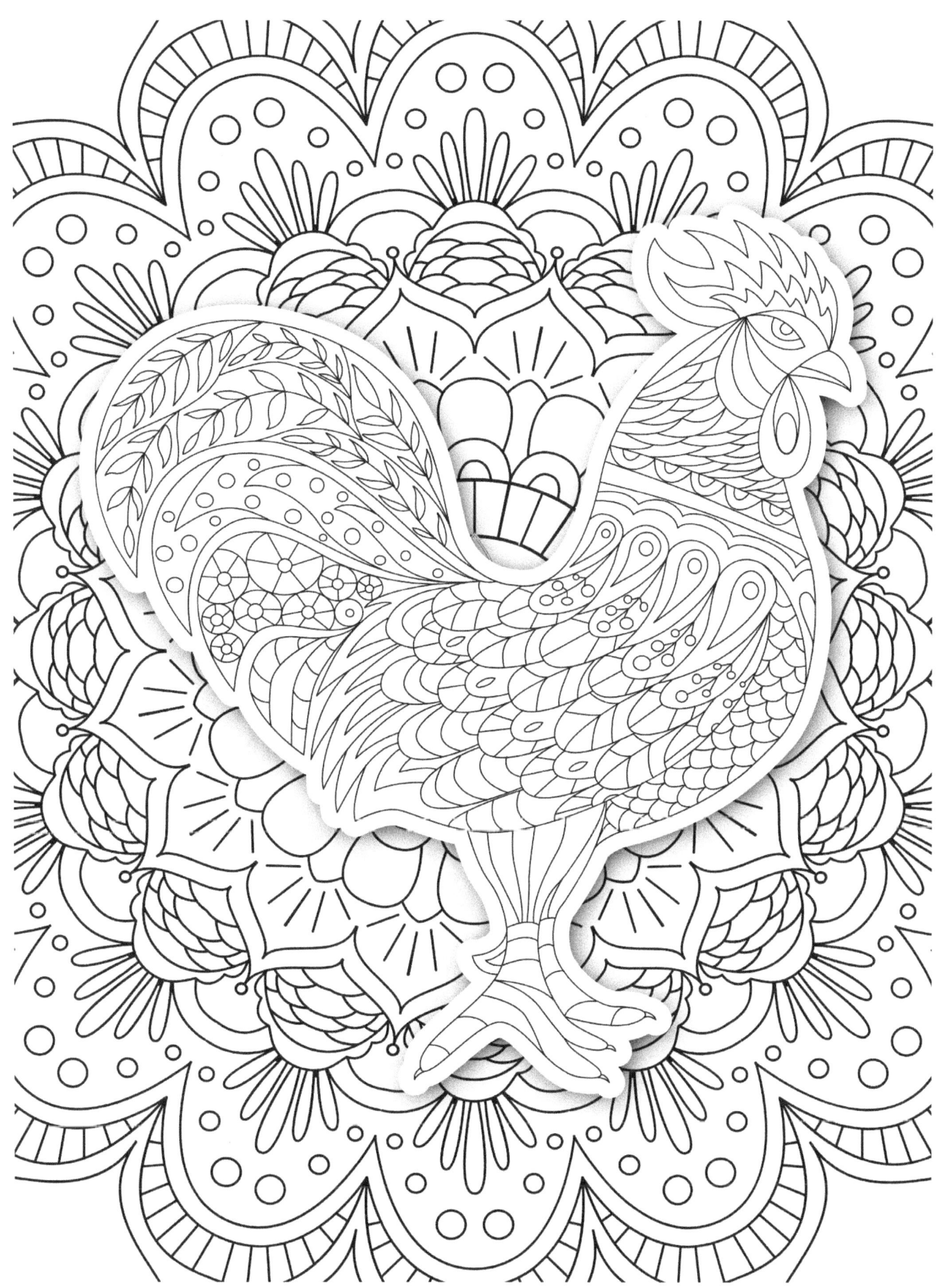

Illustration credit: Bigstockphoto.com: Sybirko- 120072879

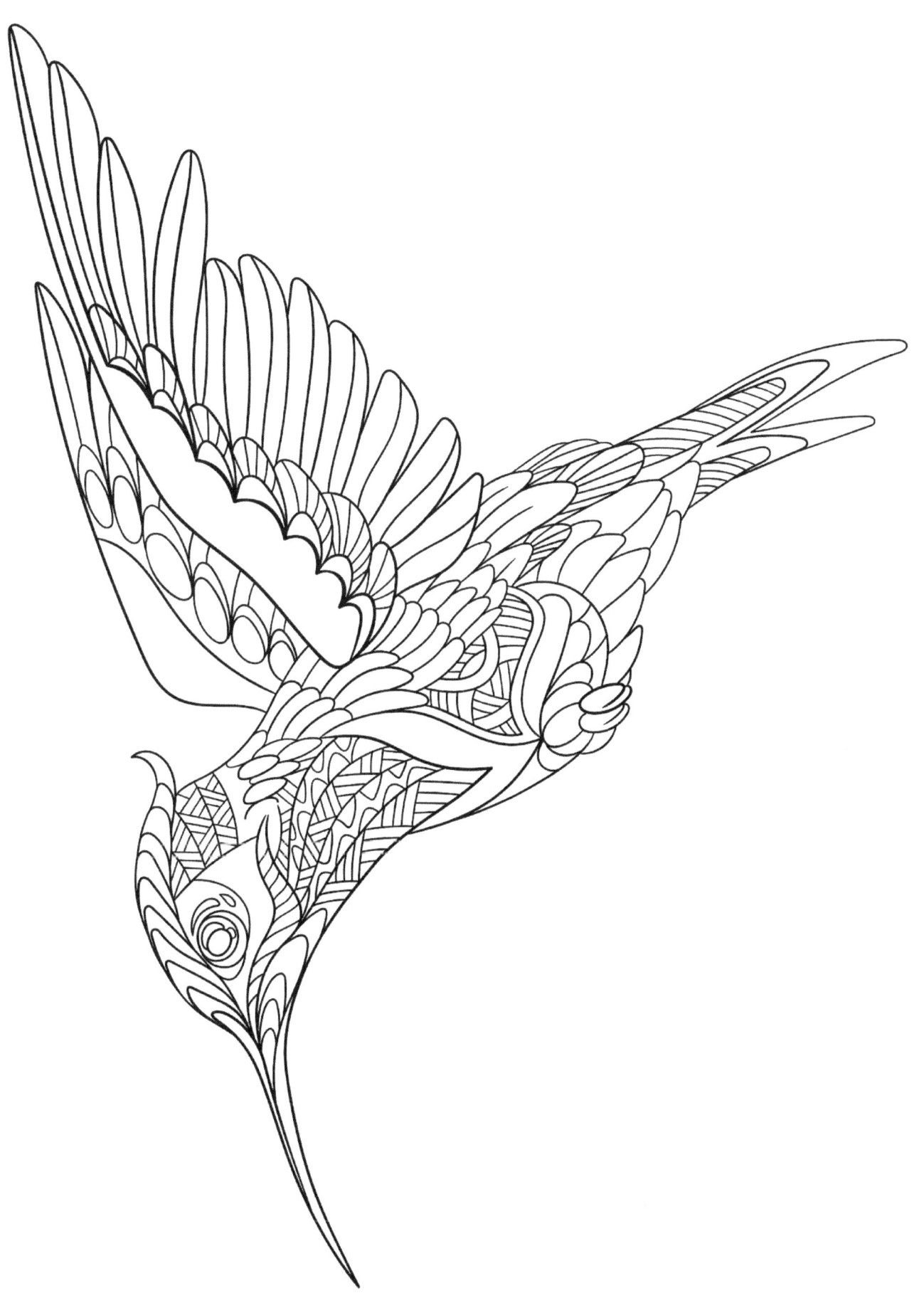

Illustration credit: Bigstockphoto.com: AnVino- 136515515

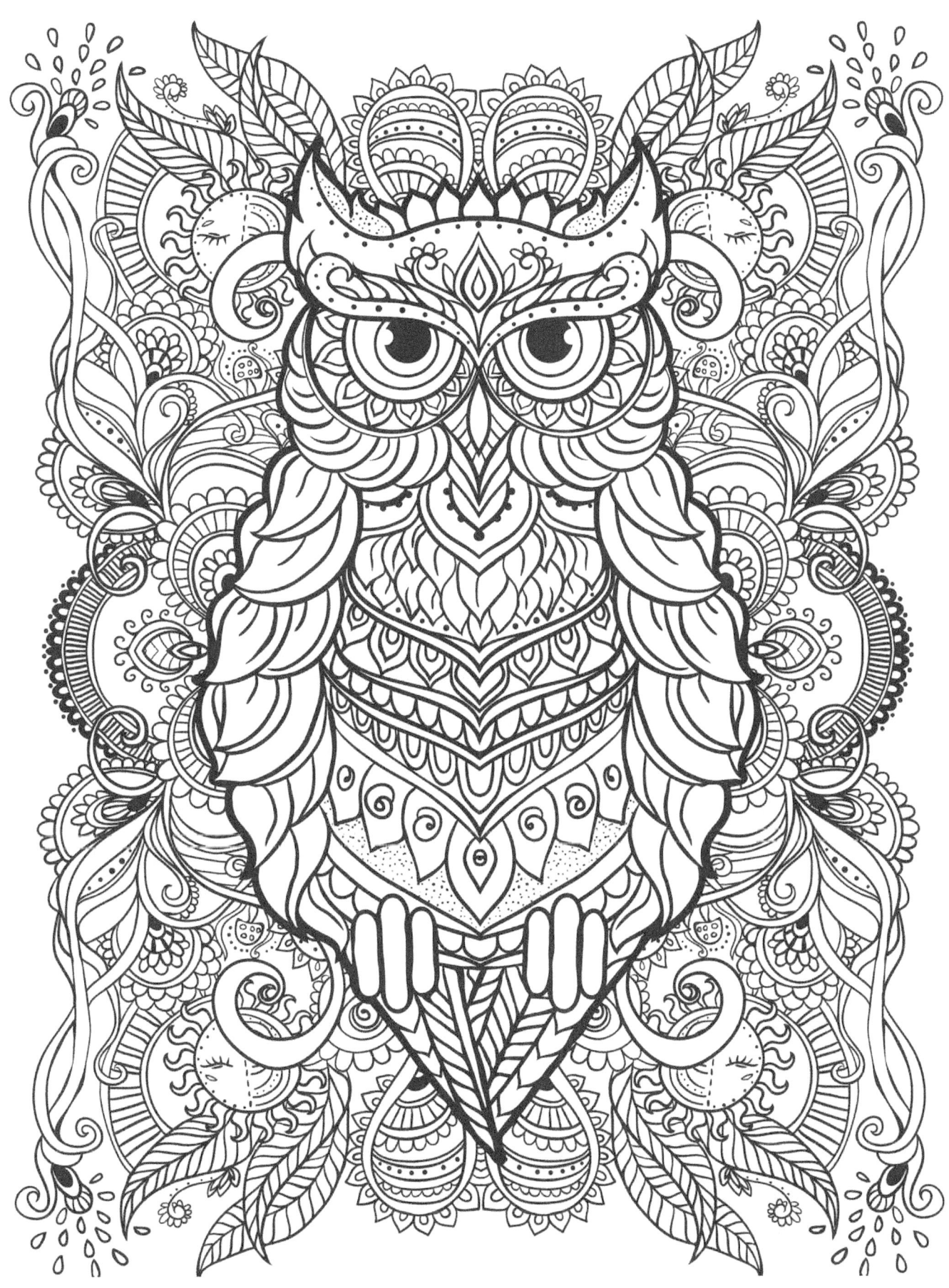

Illustration credit: Bigstockphoto.com: panki- 128504012

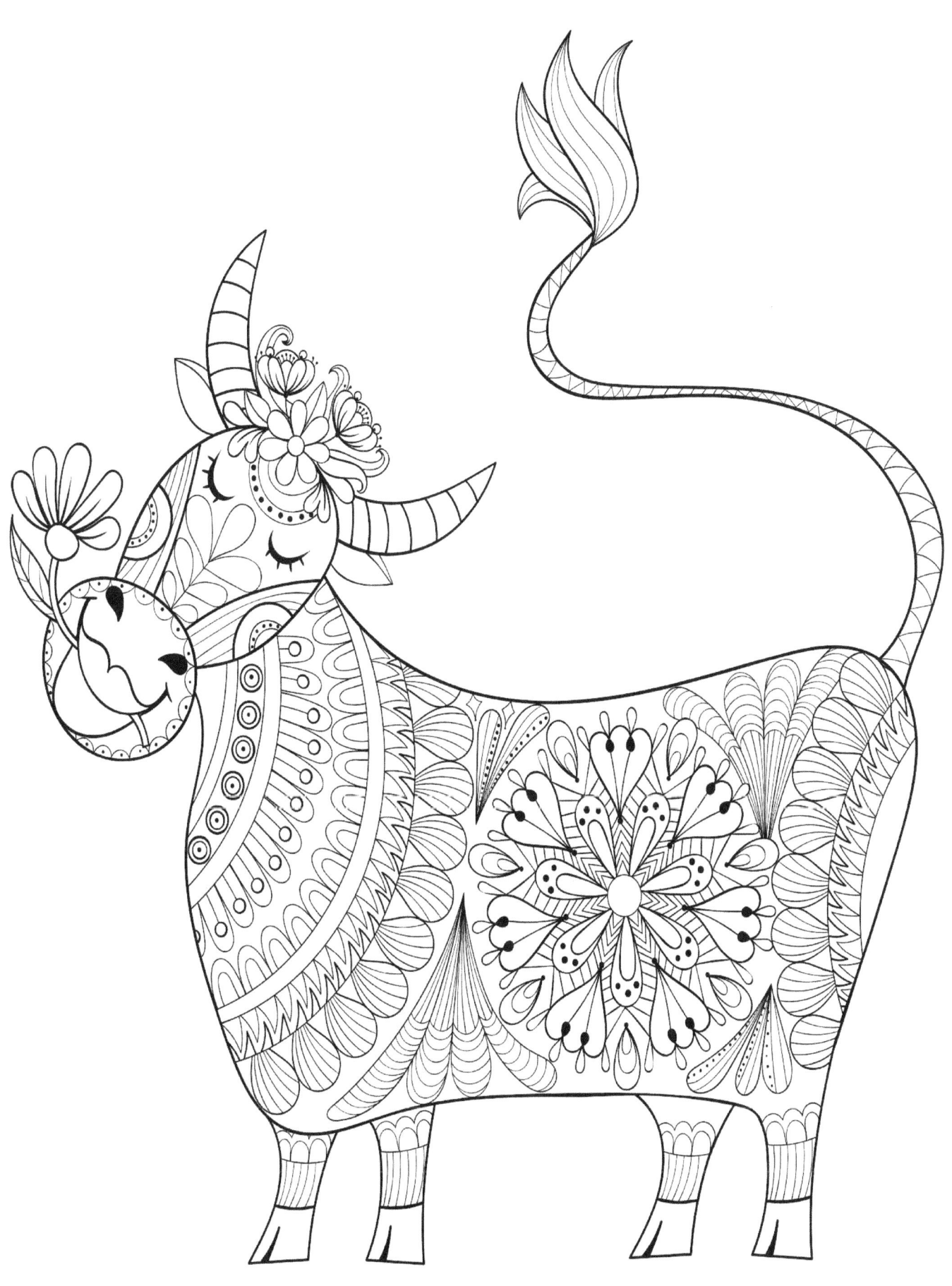

Illustration credit: Bigstockphoto.com: panki- 116685575

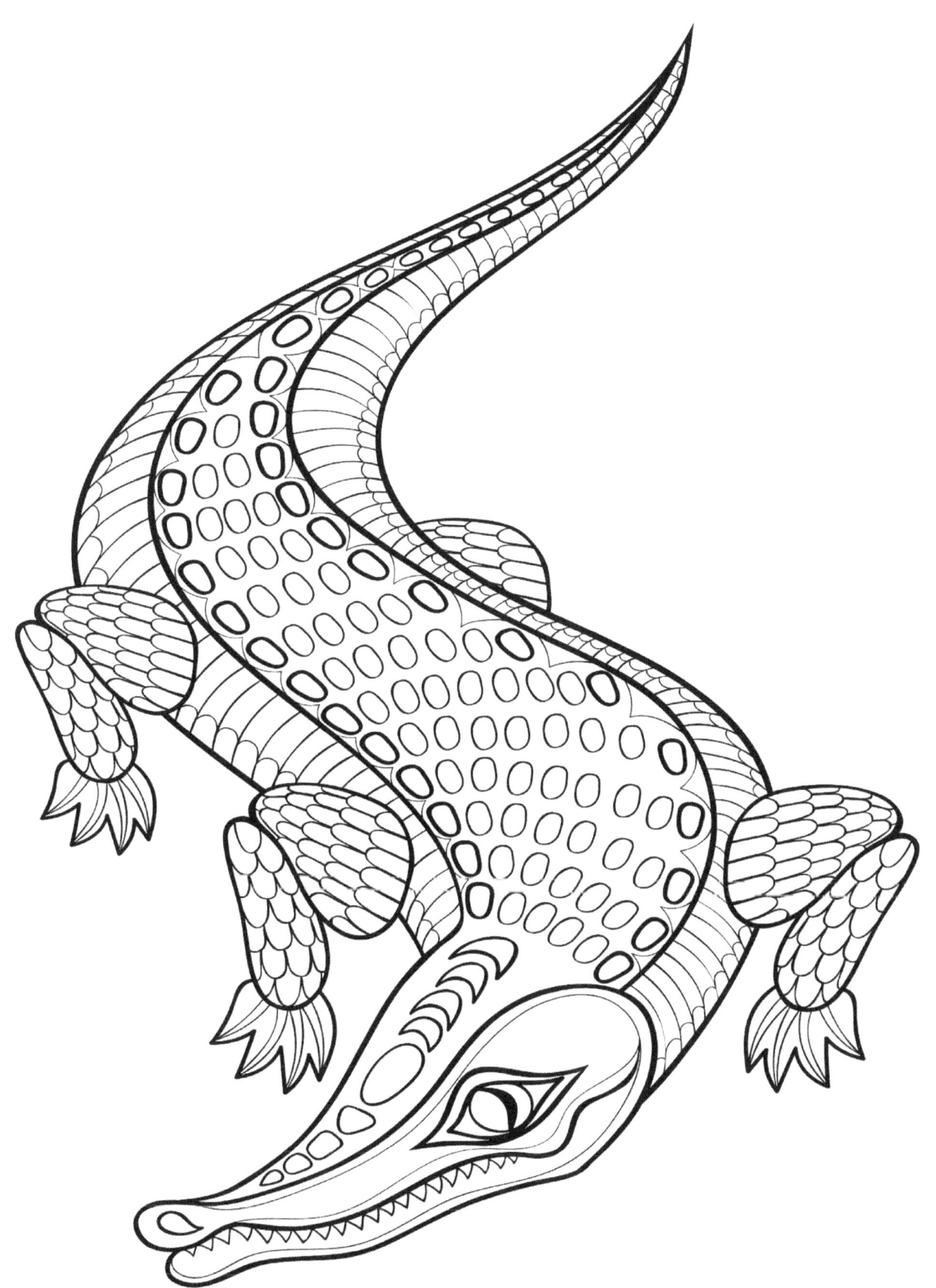

Illustration credit: Bigstockphoto.com: Alexsnail: 122162562

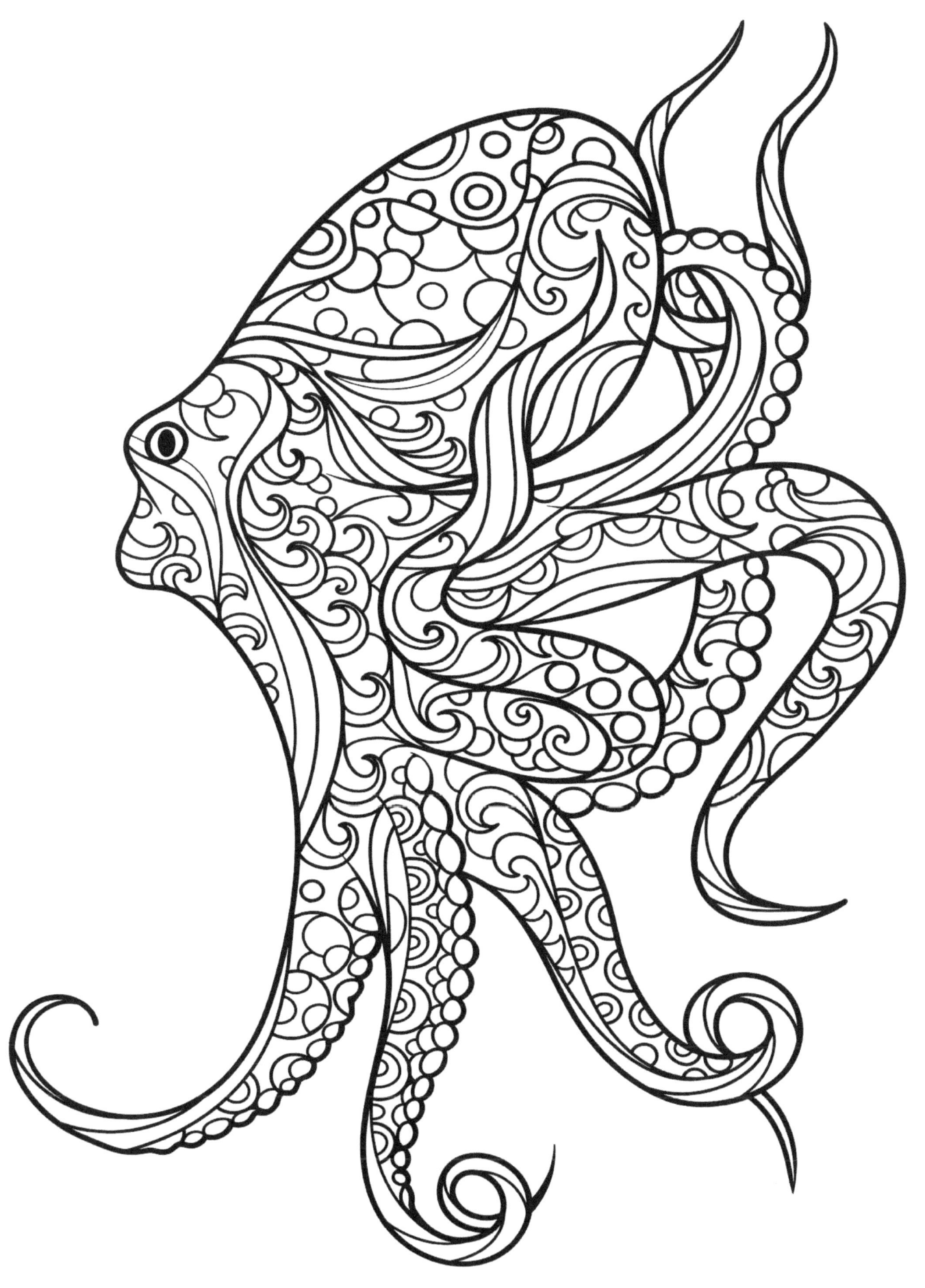

Illustration credit: Bigstockphoto.com: Son 80: 124247138

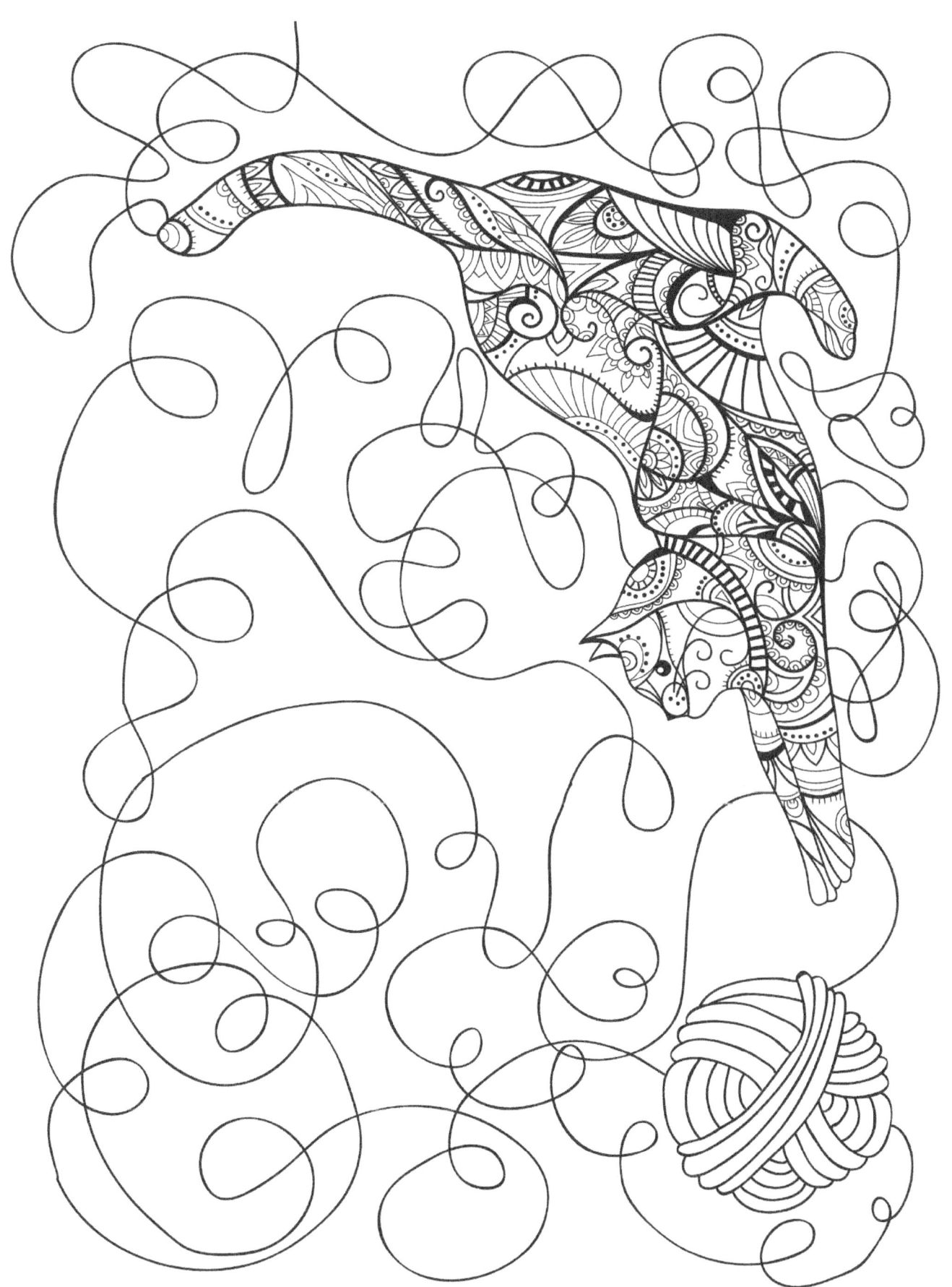

Illustration credit: Bigstockphoto.com: Son 80: 124247276

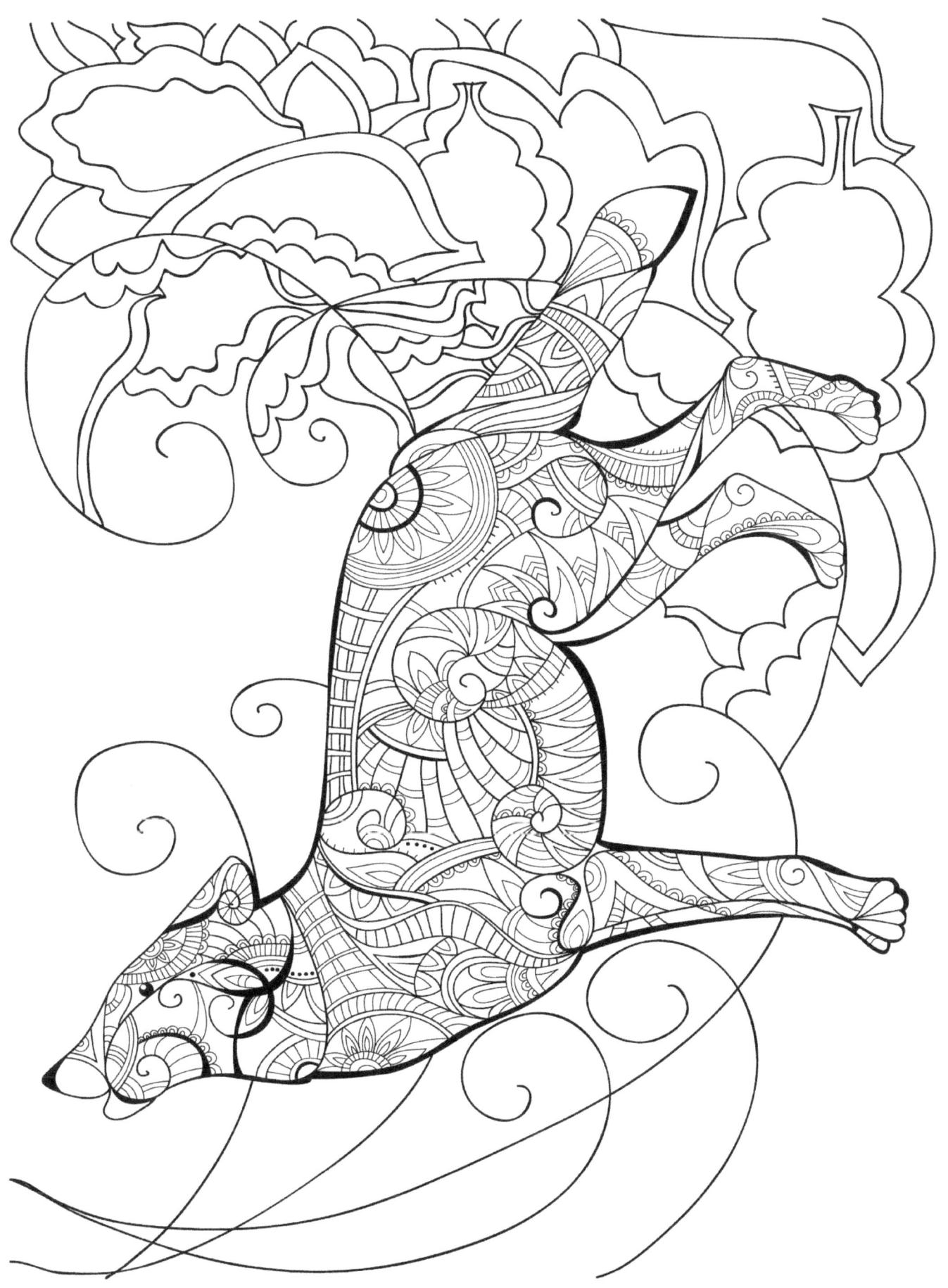

Illustration credit: Bigstockphoto.com: AnVino: 140298431

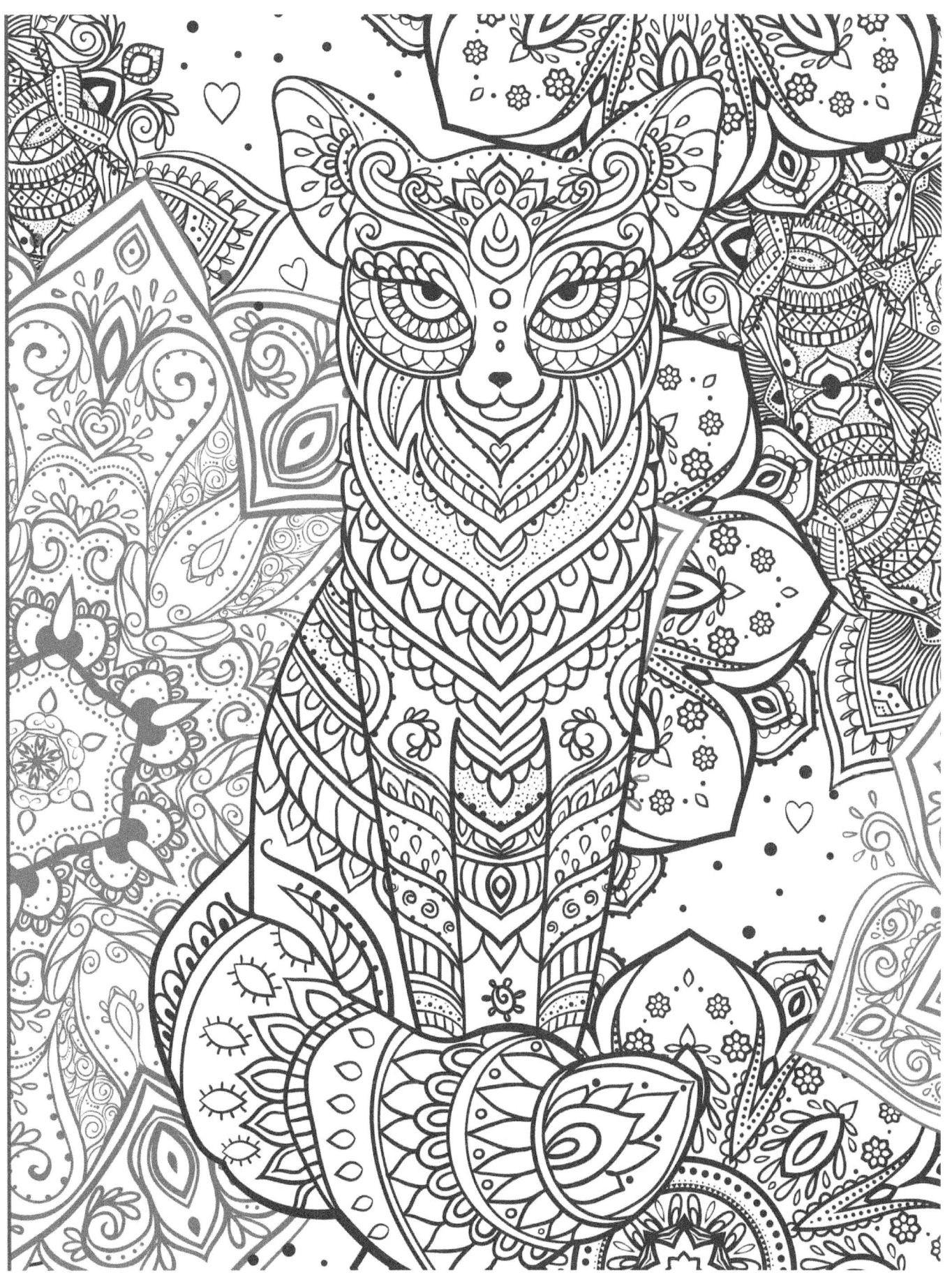

Illustration credit: Bigstockphoto.com:

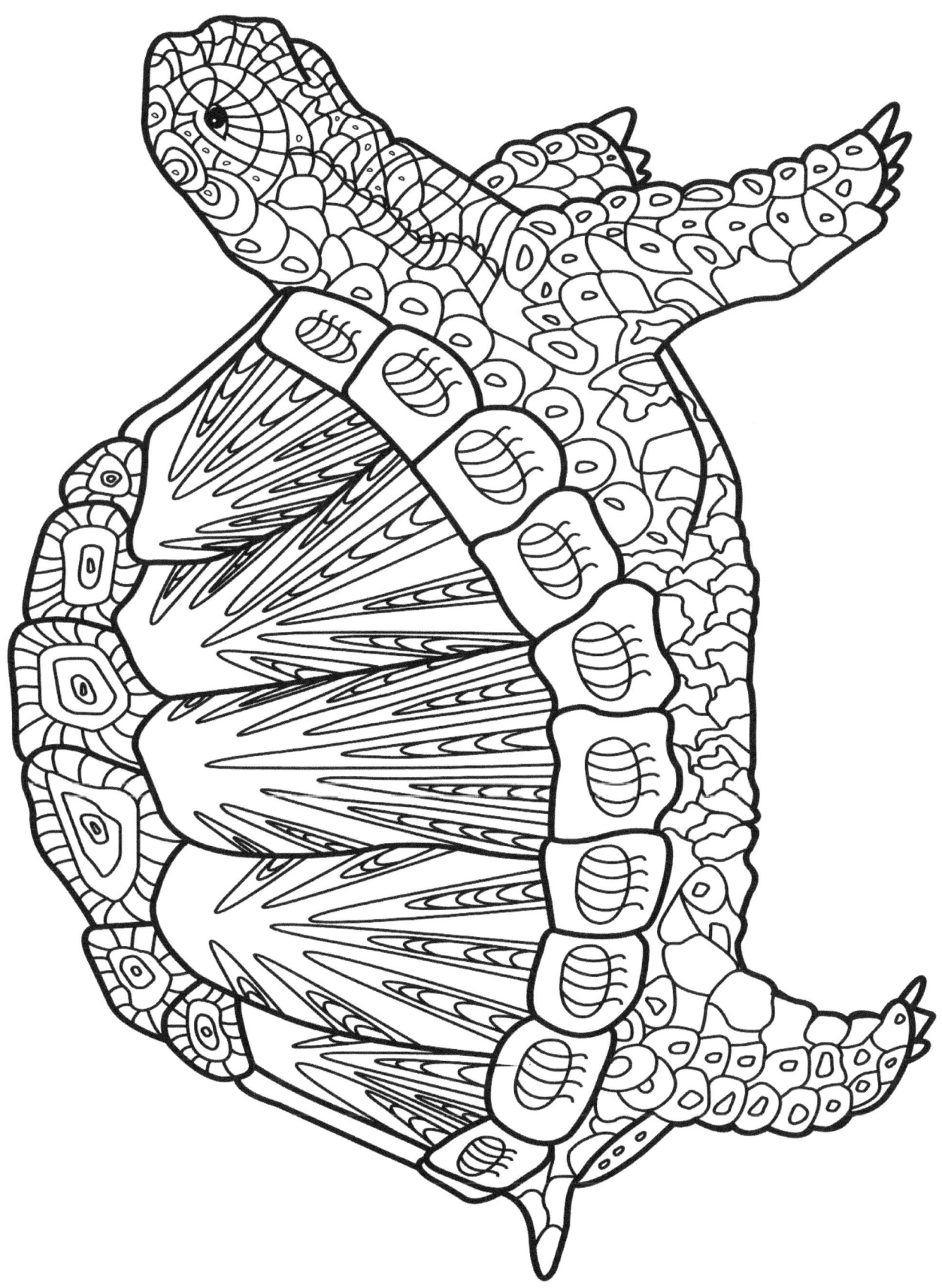

Illustration credit: Bigstockphoto.com: Sybirko: 121616612

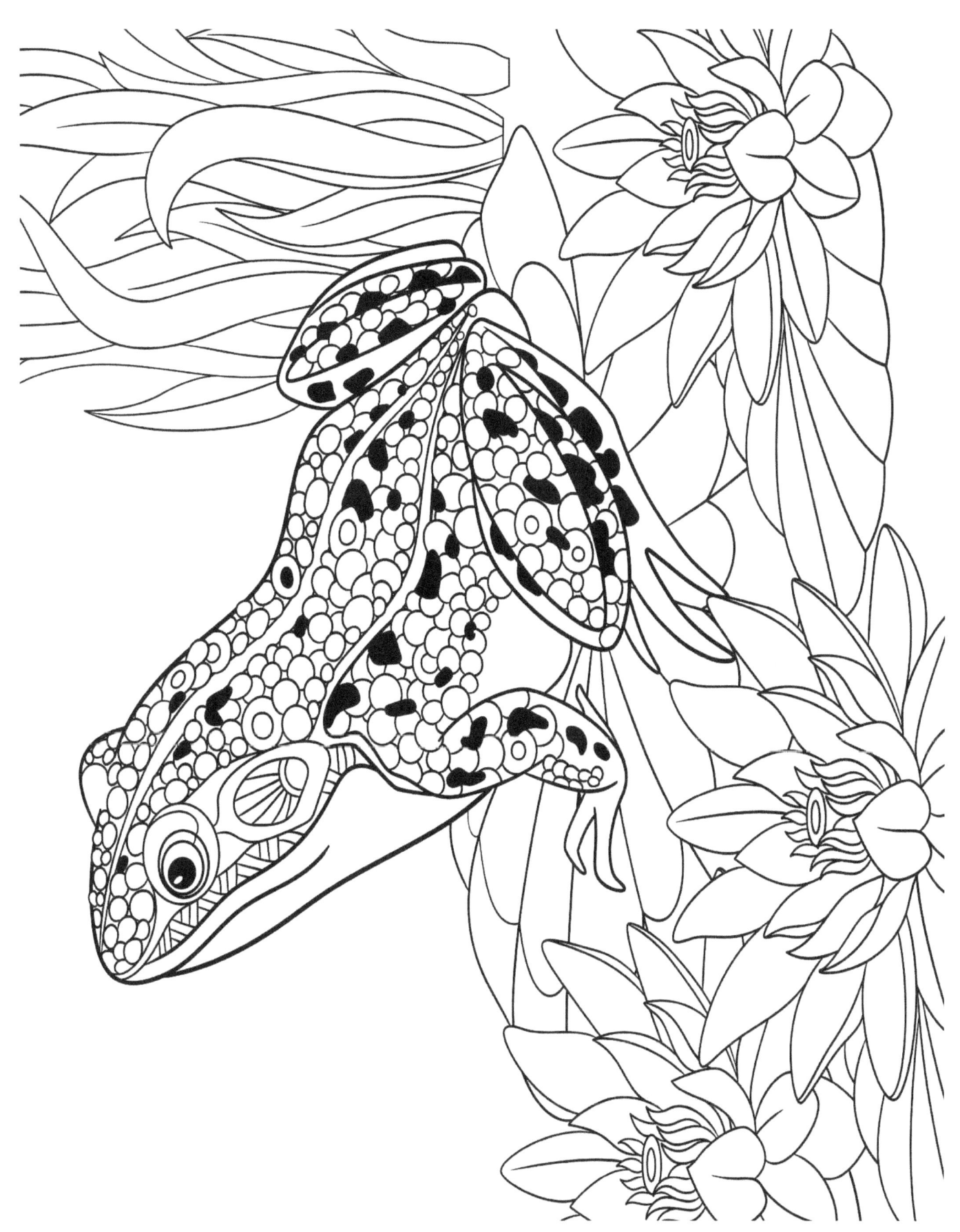

Illustration credit: Bigstockphoto.com: Alexsnail: 119578928

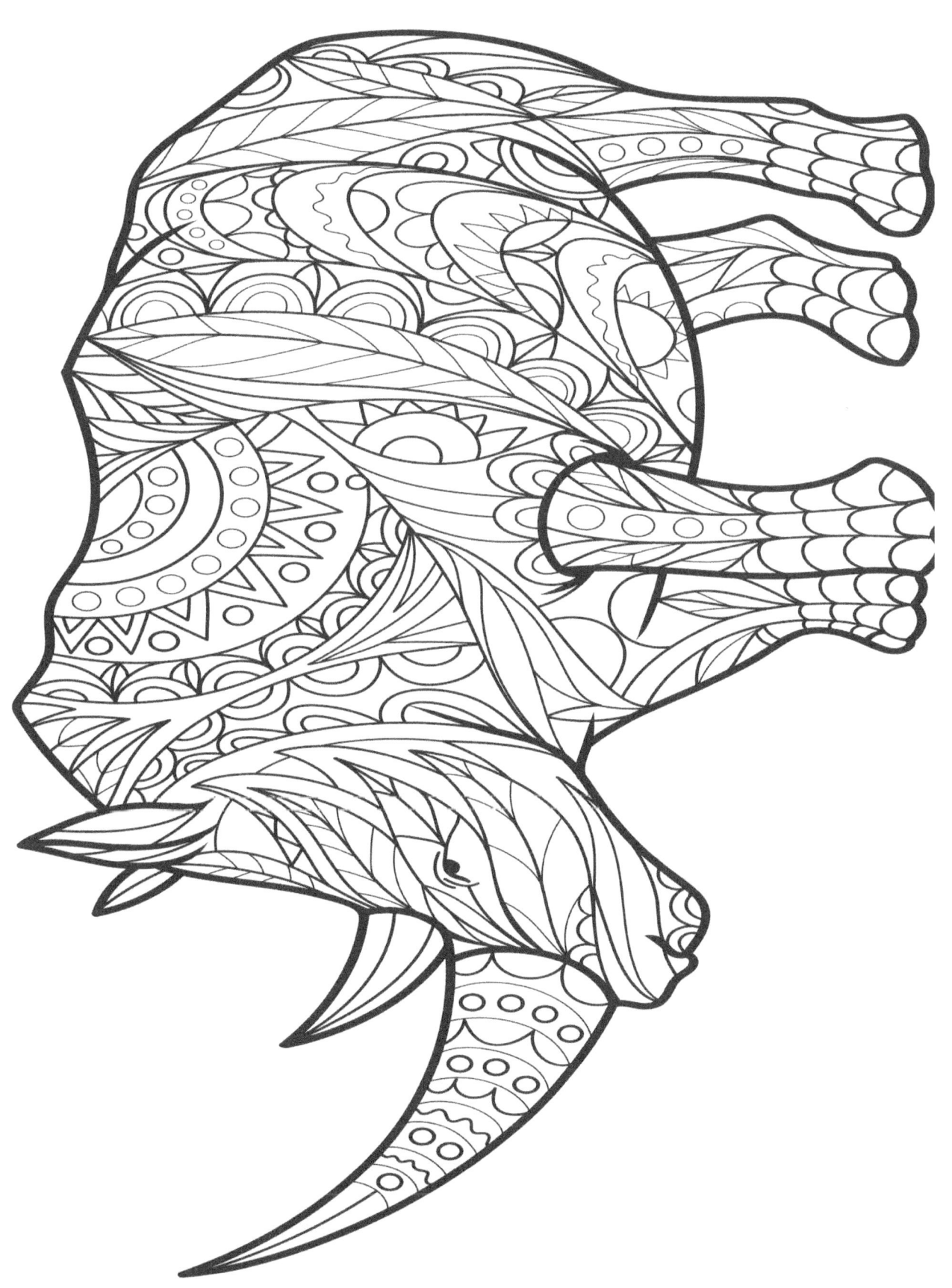

Illustration credit: Bigstockphoto.com: Alyonka_lis- 114105431

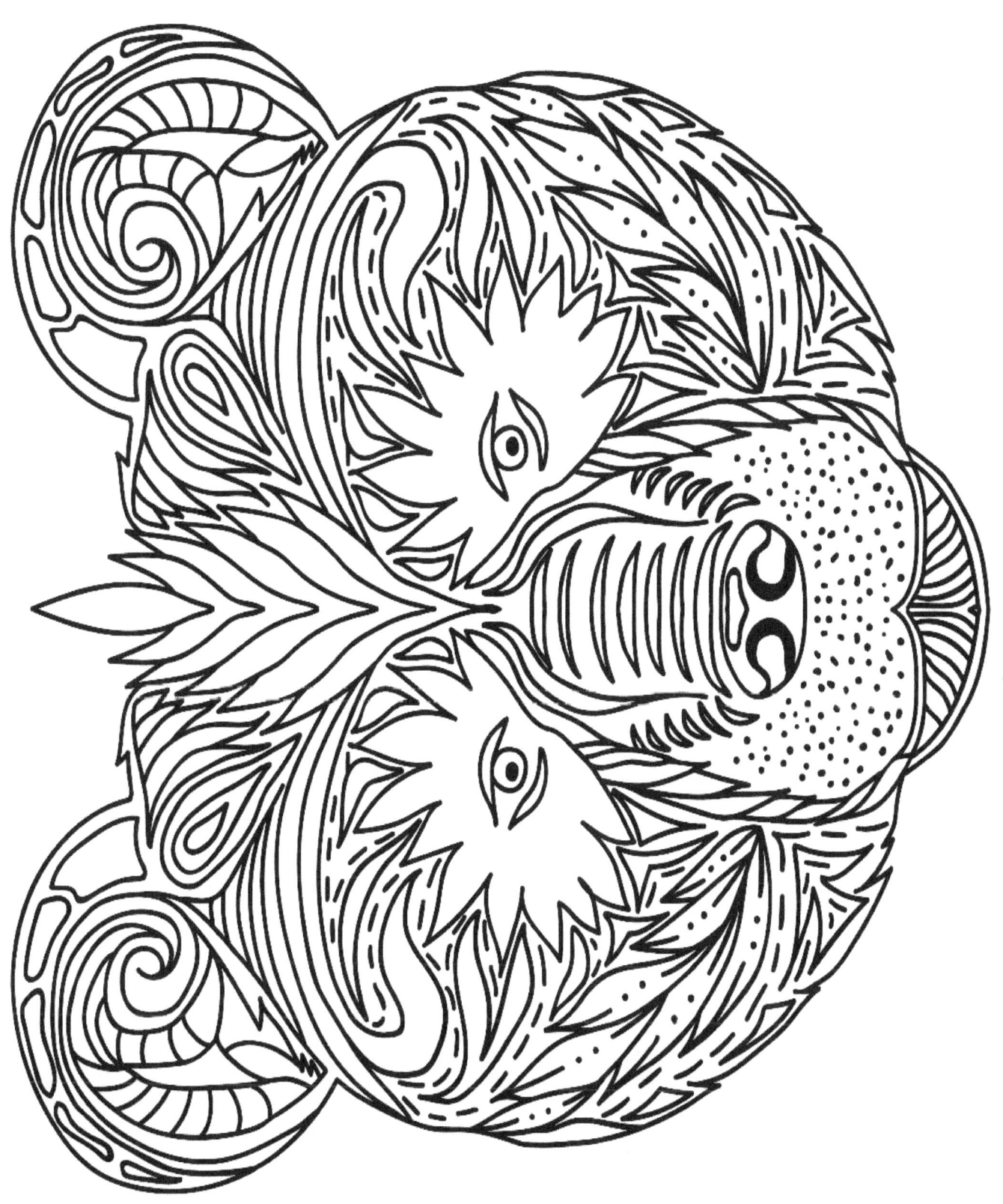

Illustration credit: Bigstockphoto.com: toricheks1 135780095

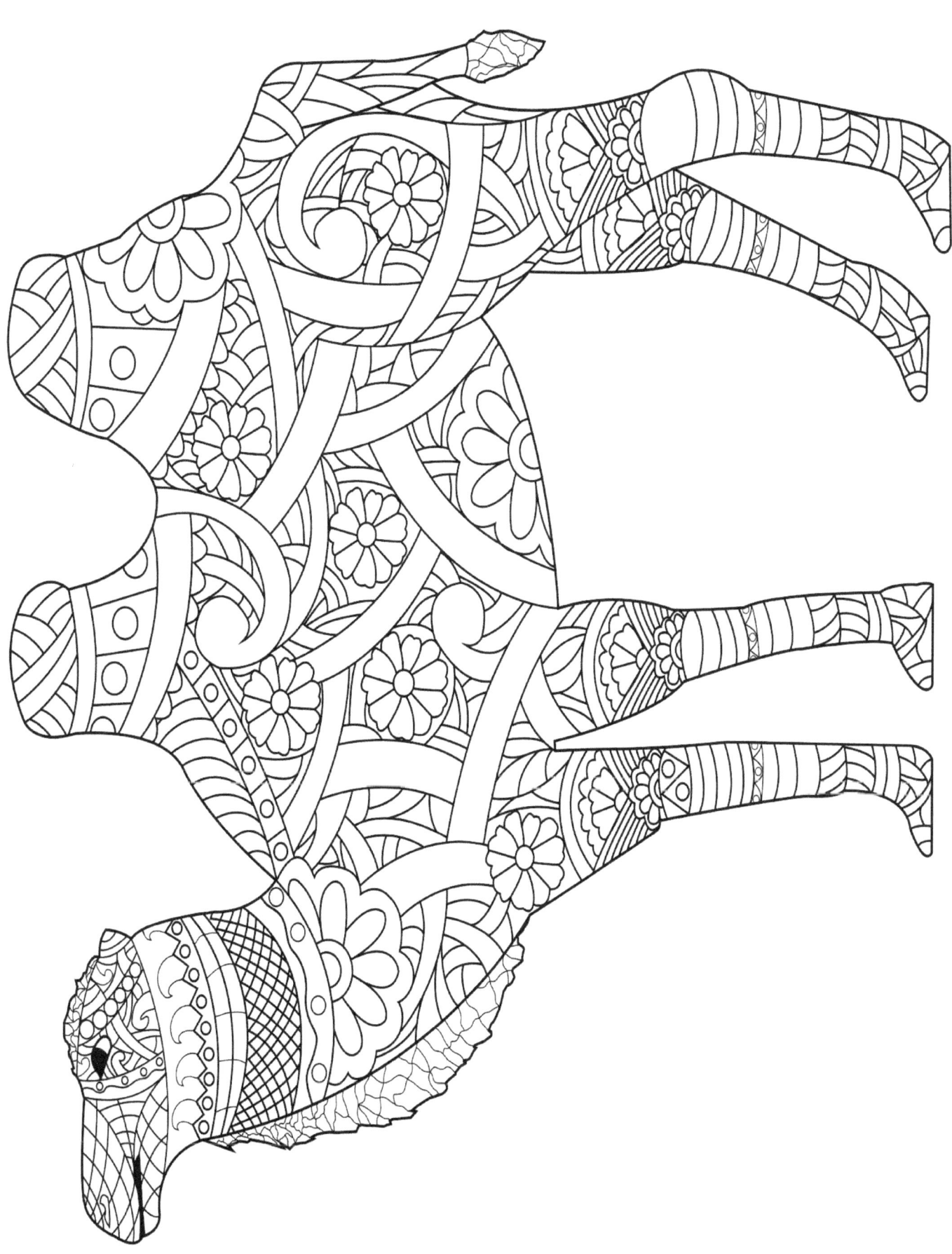

Illustration credit: Bigstockphoto.com: Dina_Asiliva- 115740554

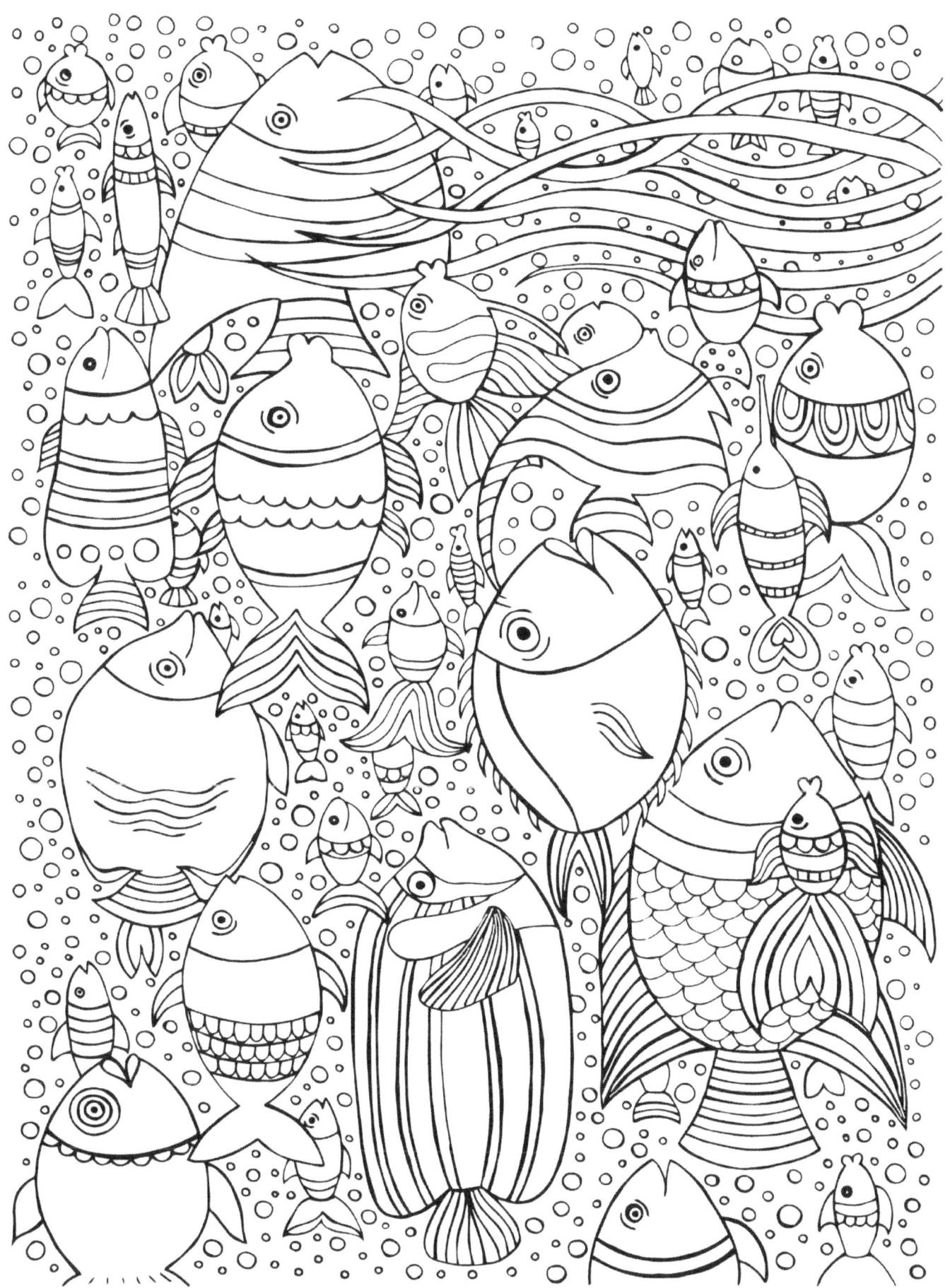

Illustration credit: Bigstockphoto.com: Sybirko- 121616555

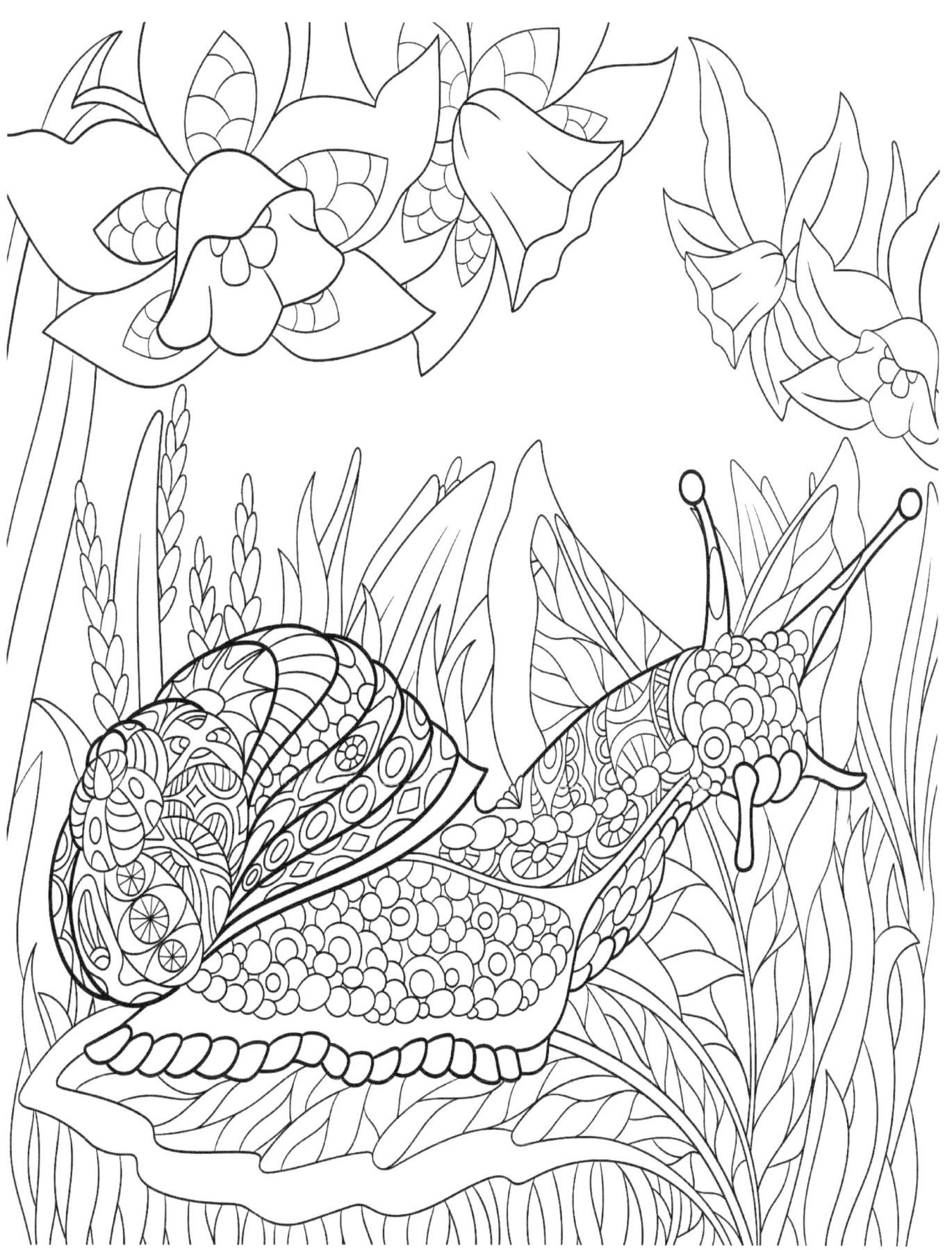

Illustration credit: Bigstockphoto.com: Viacheslav Dubrovin- 132020393

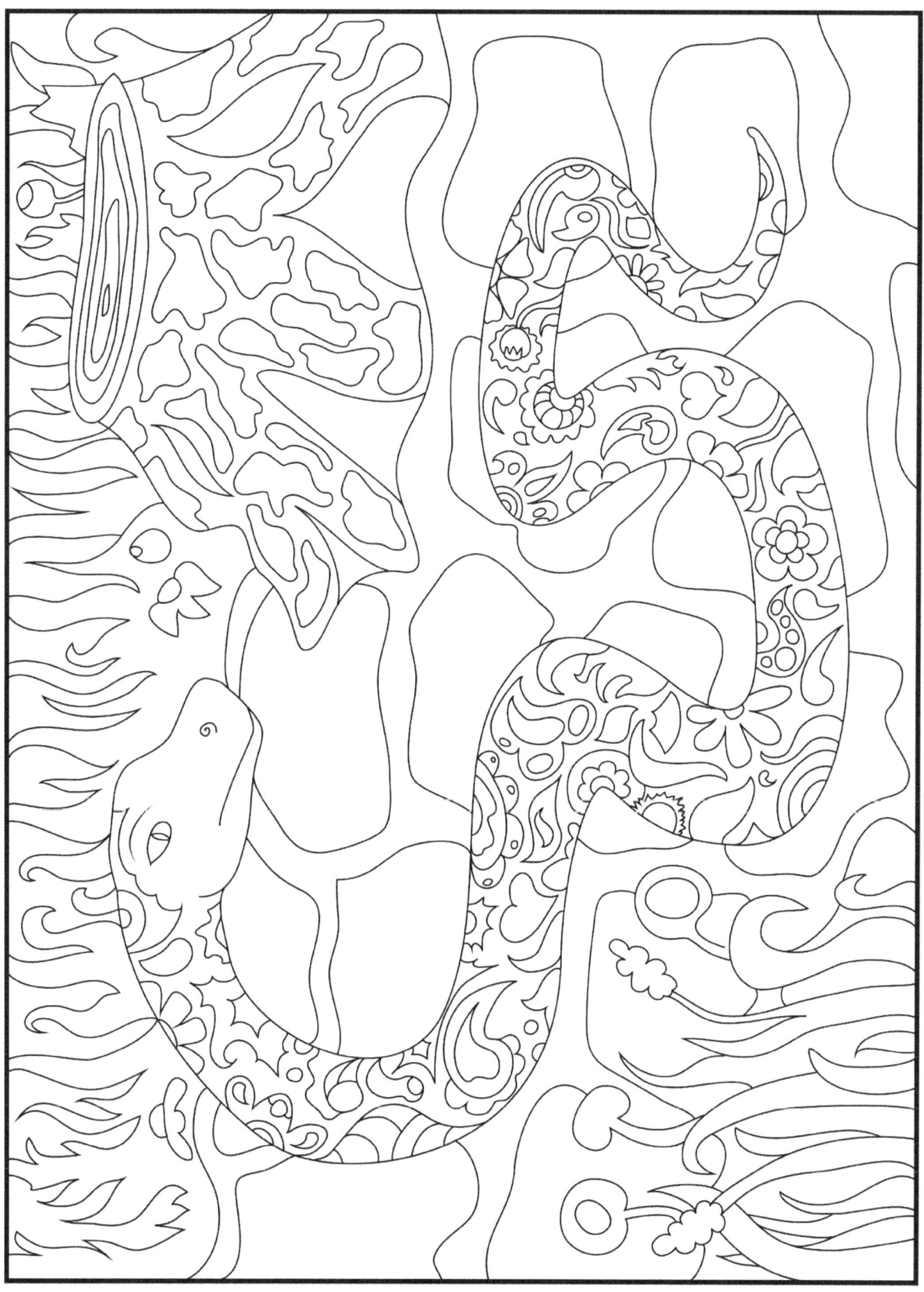

Illustration credit: Bigstockphoto.com: Viacheslav Dubrovin- 132020366

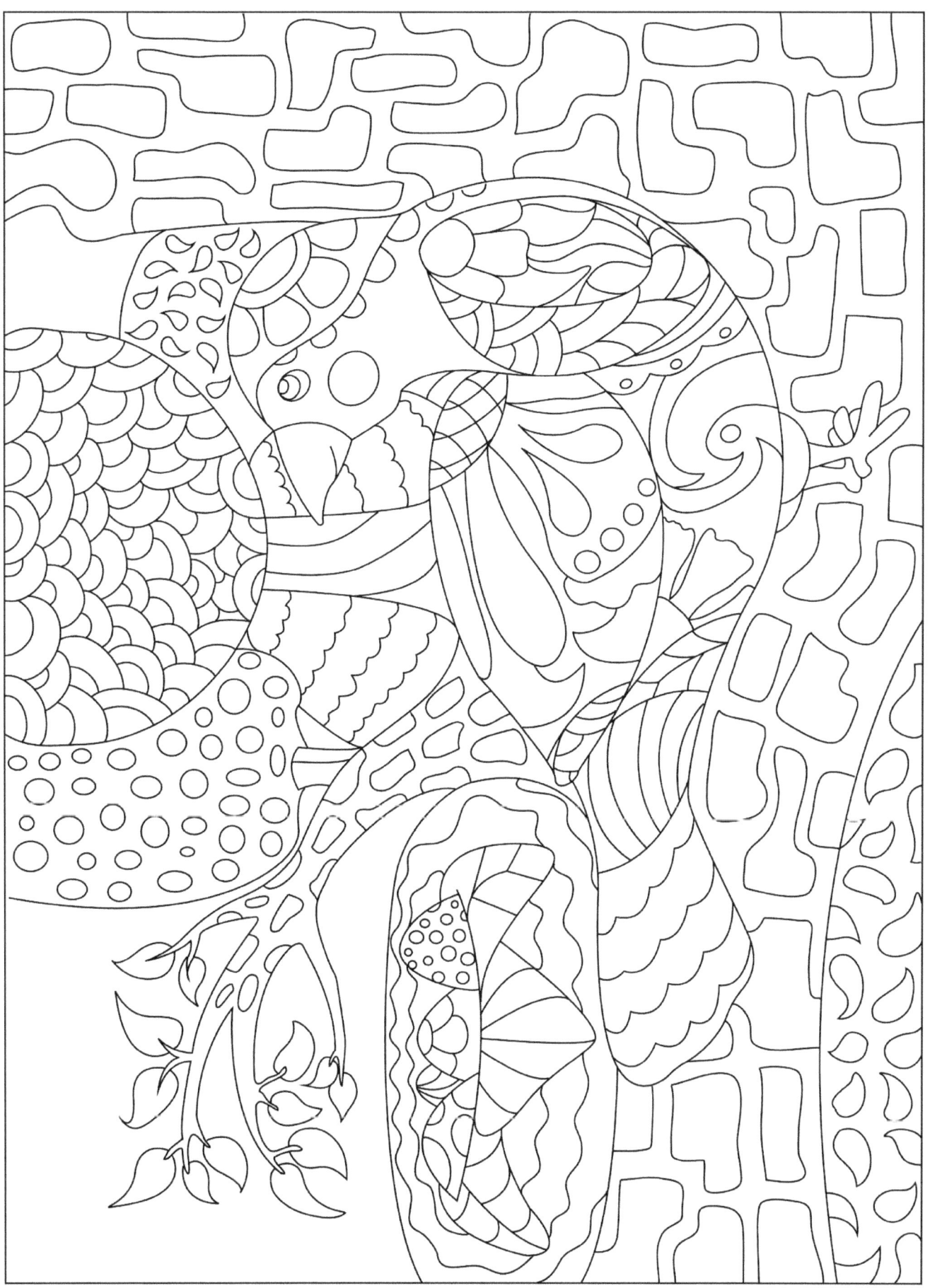

Illustration credit: Bigstockphoto.com: panki- 116673524

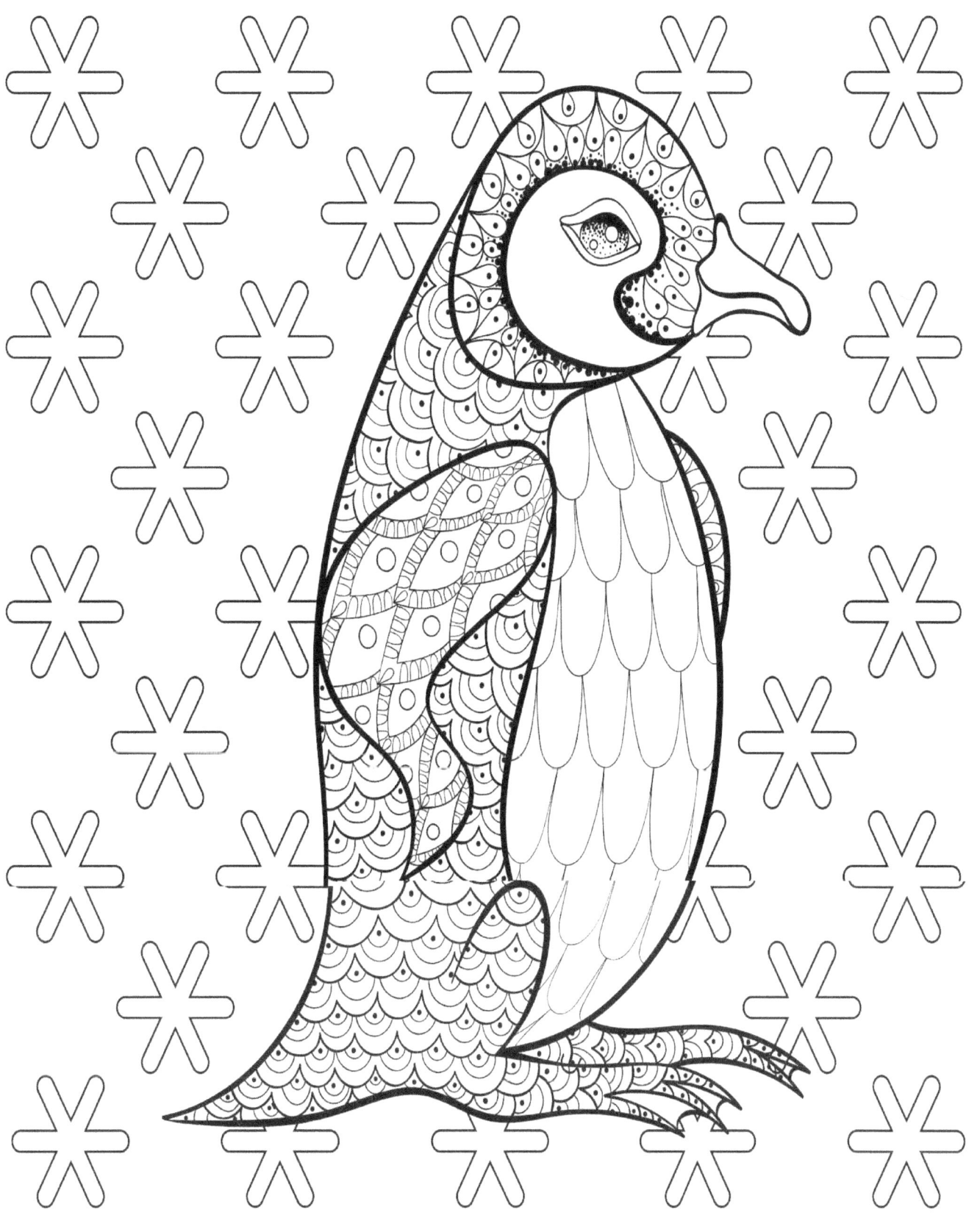

Illustration credit: Bigstockphoto.com: totally pic- 1286302222

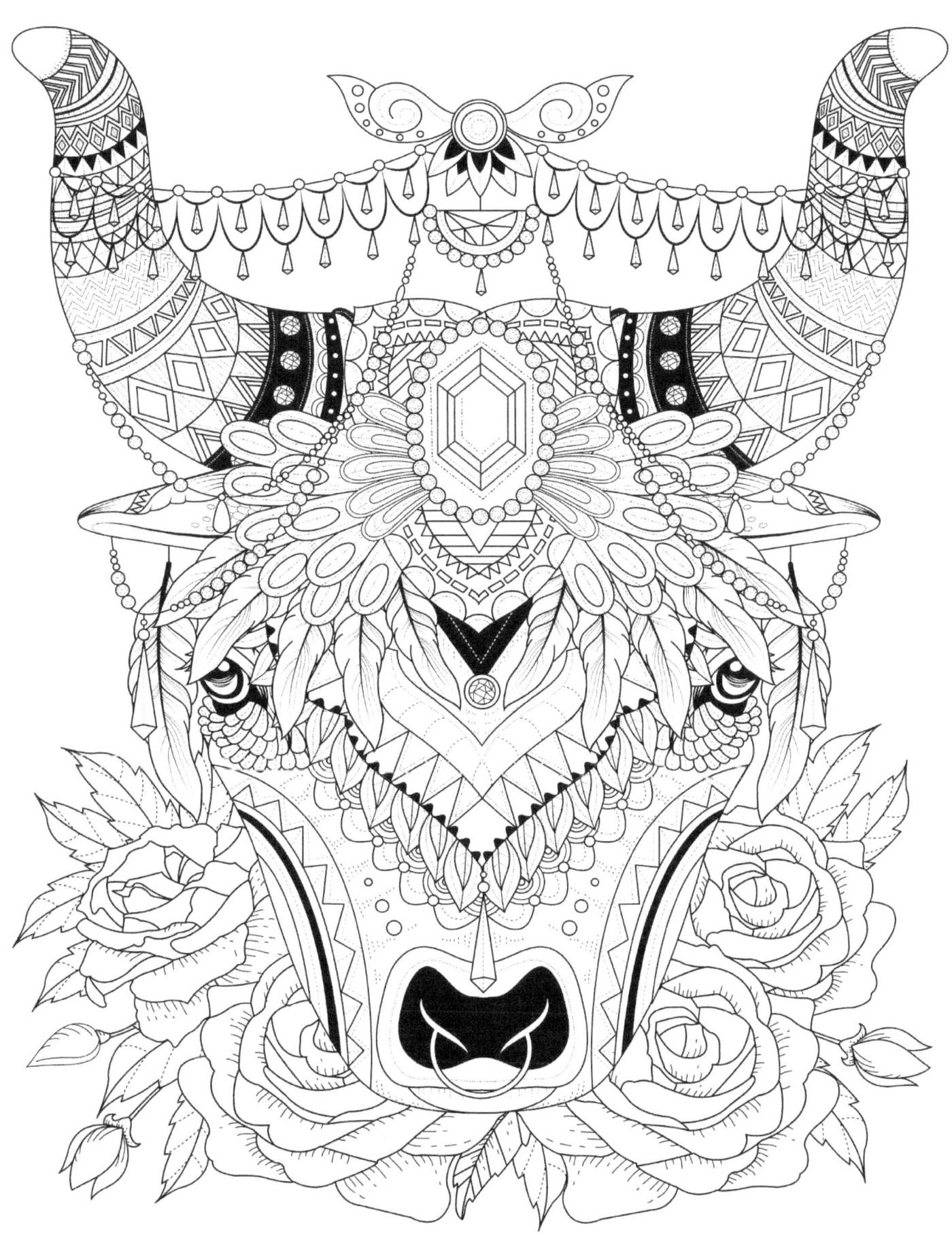

Illustration credit: Bigstockphoto.com: Bimbimkha_ 107823223

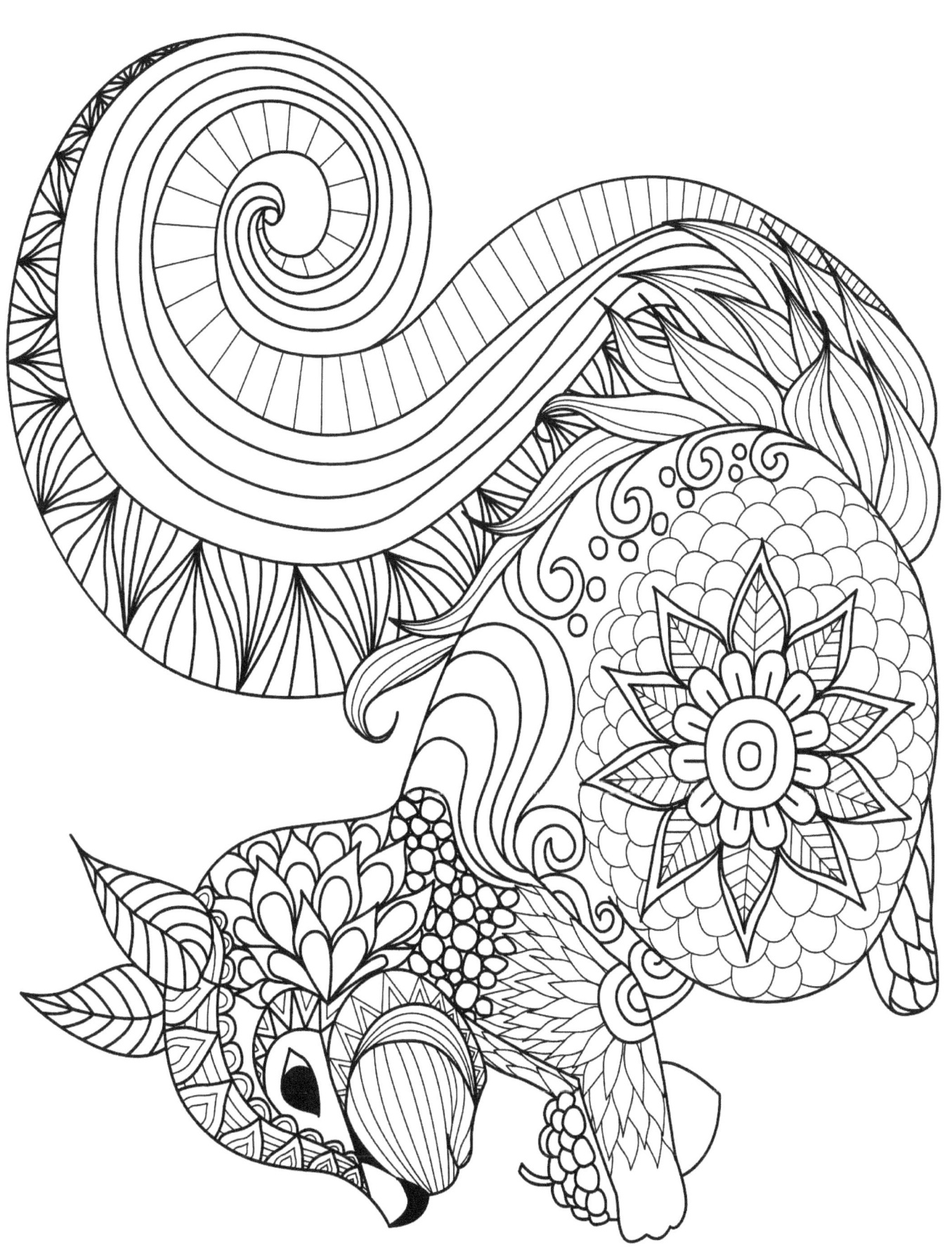

Illustration credit: Bigstockphoto.com:Sybirko- 137593682

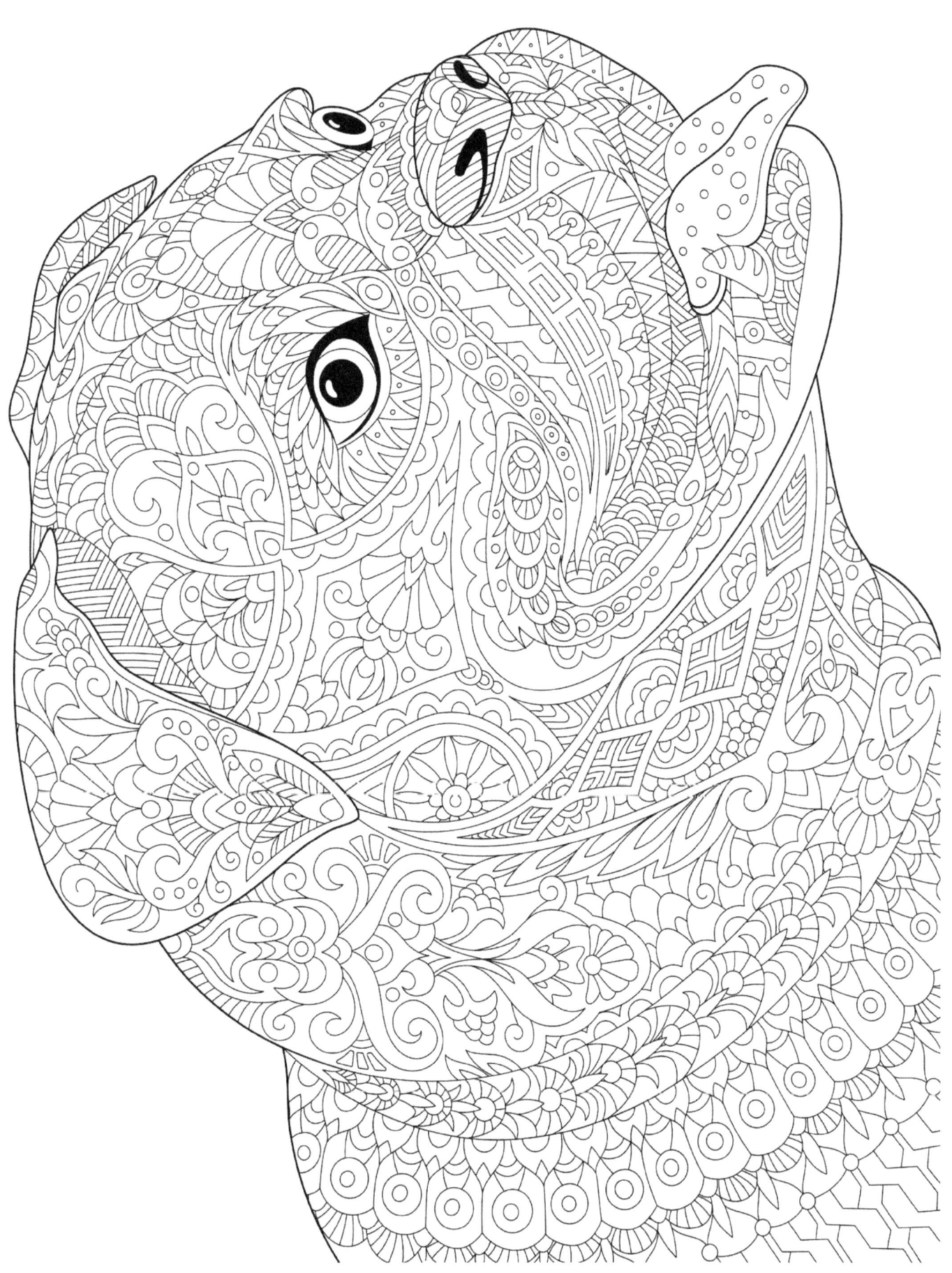

Illustration credit: Bigstockphoto.com: Bimbimkha- 113906165

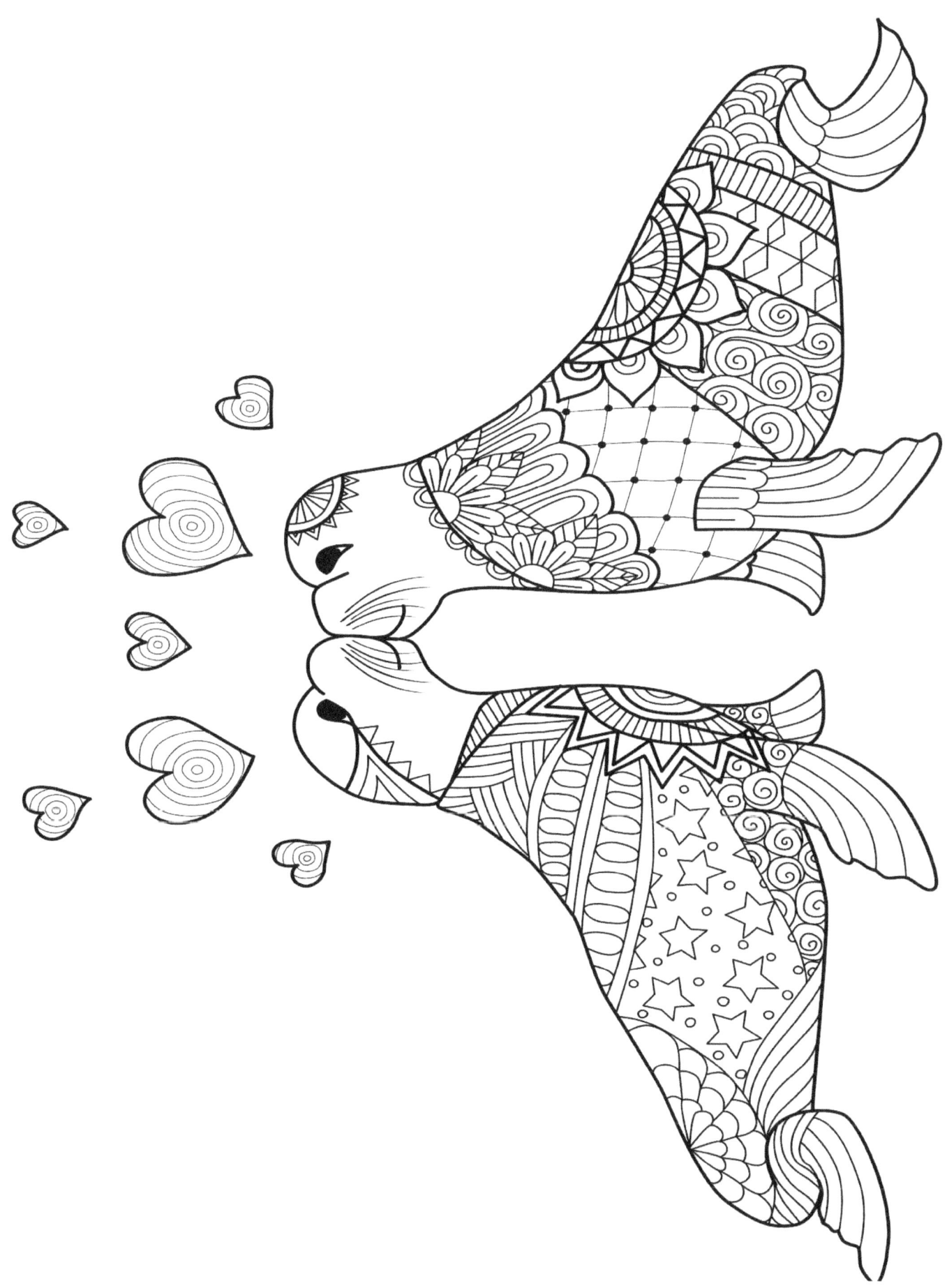

Illustration credit: Bigstockphoto.com: torickeho- 131012282

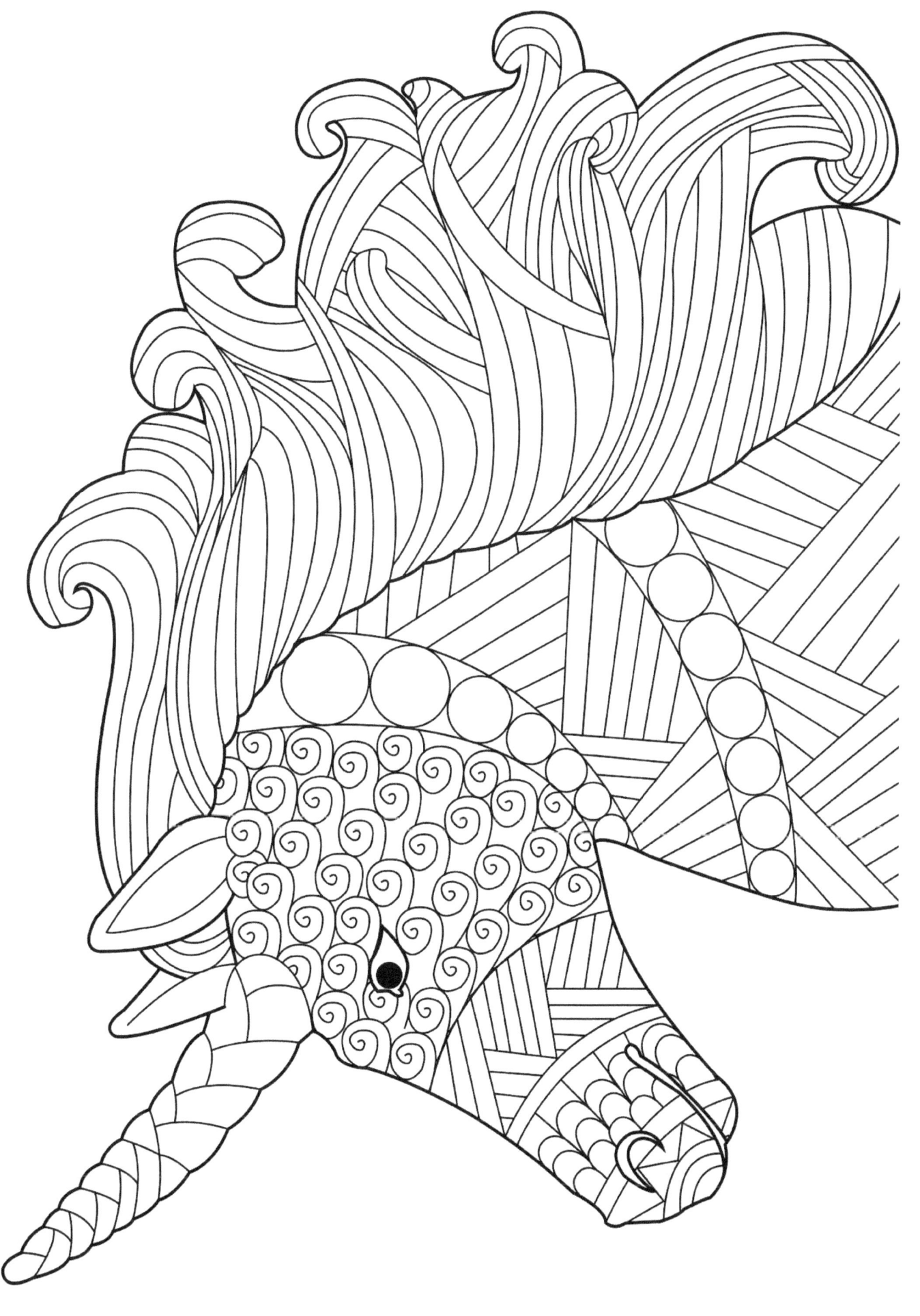

Illustration credit: Bigstockphoto.com: Sybirko- 121615805

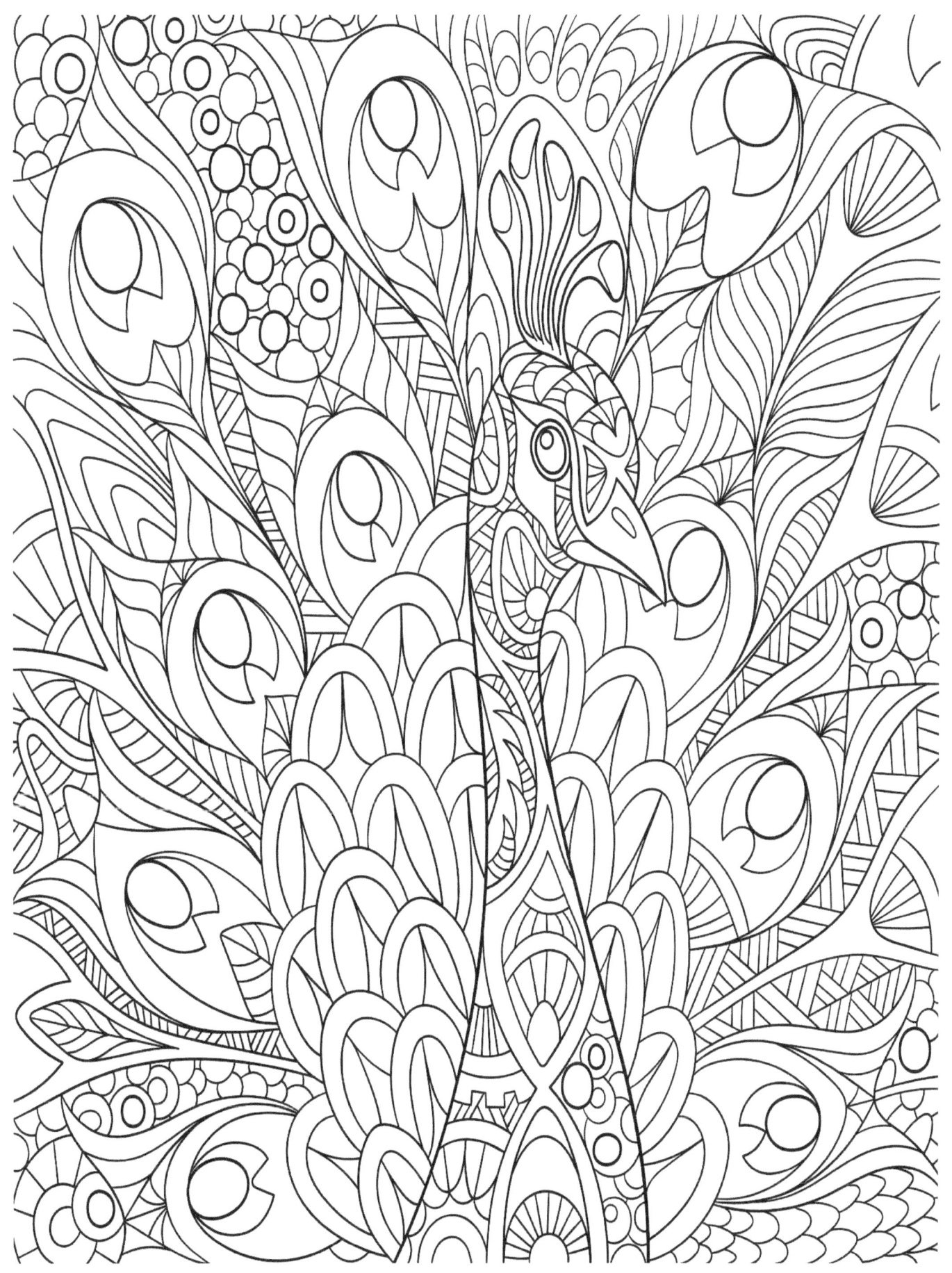

Illustration credit: Bigstockphoto.com: Sybirko- 123939137

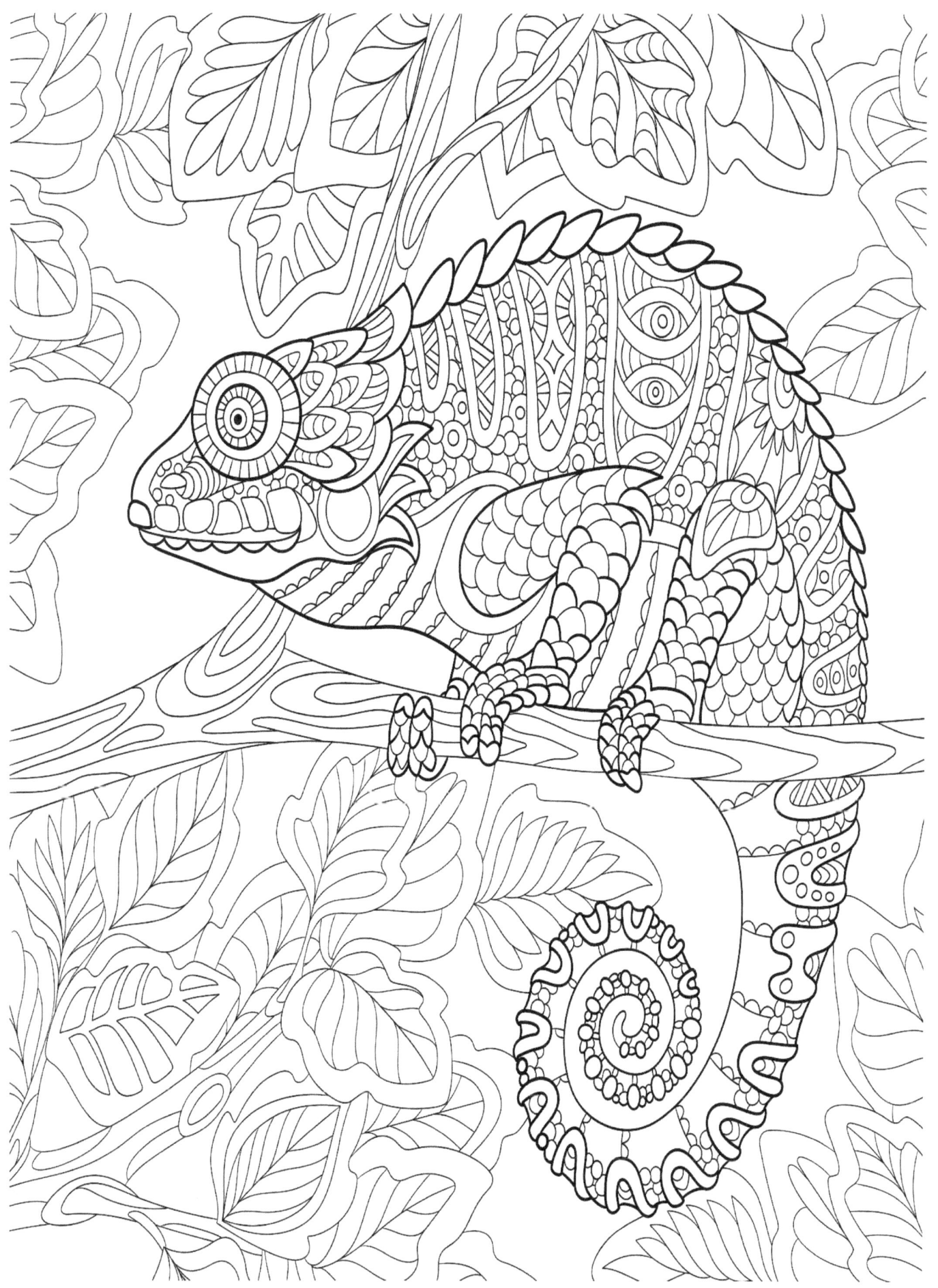

Illustration credit: Bigstockphoto.com: Bimbimkha- 105327353

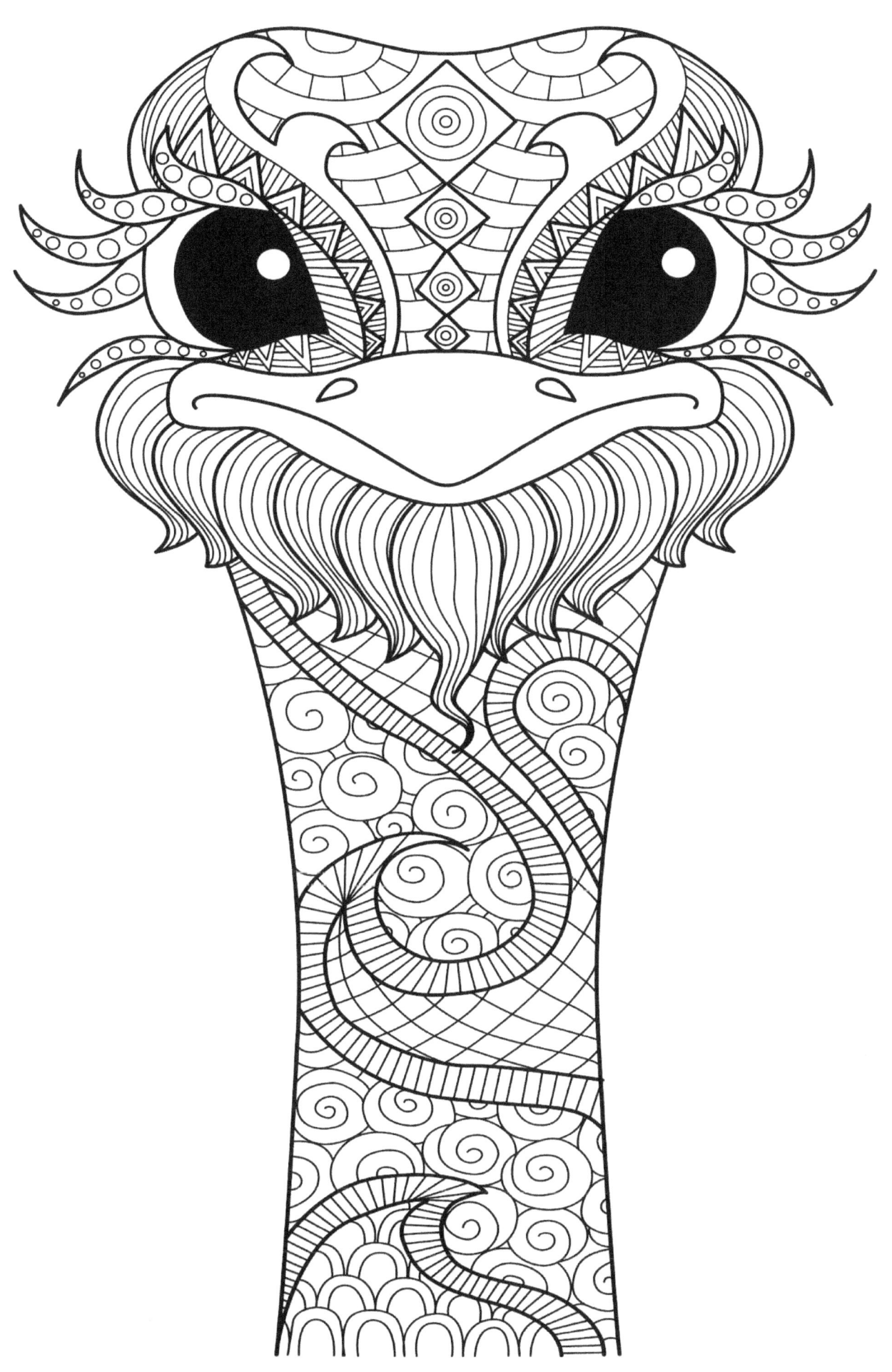

www.ingramcontent.com/pod-product-compliance
Lightning Source LLC
Chambersburg PA
CBHW080544190526
45169CB00007B/2622